Nature's Guide to Healing

BY GARY ROSS, M.D.

Foreword by Michael T. Murray, N.D.

Disclaimer: The material in this presentation is for informational purposes only and not intended for the treatment or diagnosis of individual disease. Please, visit a qualified medical or other health professional for specifically diagnosing any ailments mentioned or discussed in this material.

This information is presented by an independent medical expert whose sources of information include scientific studies from the world's medical and scientific literature, patients and other clinical reports.

Note: It is important to consult with your healthcare practitioner before taking any herbal preparation. Pregnant women should consult with their physician before using the herbs listed herein.

First Printing, September 2000

ISBN 1-893910-06-7

Published by Freedom Press
1801 Chart Trail
Topanga, CA 90290
Bulk Orders Available: (310) 455-2995 / (800) 959-9797
E-mail: sales@freedompressonline.com

Cover (clockwise from top left): cat's claw, black elderberry, lemon balm, schisandra, peppermint, milk thistle, horse chestnut

Contents

Acknowledgments

It is with great gratitude that I acknowledge the many herbalists and scientists who have dedicated their lives to researching the scientific merits of herbs and their use in modern day medicine and healing. The lives of countless individuals are improved due to the dedication of these professionals and their willingness to forge new understandings of ancient wisdom. As we enter the new millennium, and ever more advances in technology visit our daily lives, it is important—indeed, critical—that we not forget the multitude of healing remedies the earth has to share.

I'd also like to thank the following persons for their dedication to this project including Susan Reinfeldt and Mary Dumas for their research and editorial assistance without which this project would not exist; Terry Lemerond for a multitude of reasons, including his personal encouragement and support as well as his dedication to changing medicine in America; Michael Murray for scientifically documenting the principles of natural medicine; David Steinman for his care, effort and integrity in editing and publishing this guide; Steven Foster for his photography; my lovely wife Kathleen Ross for her support and assistance in writing and editing this manuscript; and, of course, my patients who've helped to lead me upon a pathway of learning and healing that I hope embodies all of the very highest principles of the practice of medicine.

The Emergence of Herbal Medicine in America

The human-plant relationship is perhaps one of the least emphasized in our earthly relationship. Yet, plants convert the energy of sunlight into chemical energy through the process of photosynthesis and, as a result, fuel life on our earth. Plants also provide a bounty of essential nutrients without which we would surely die, as well as many healing substances, called phytochemicals, that have aided men and women in their healing quest since the beginning of time. Clearly, we owe a tremendous debt to plant life.

The World Health Organization has estimated that perhaps as high as 80 percent of the world's total population regularly uses herbal medicines. This widespread use of herbal medicines is not restricted to developing nations, either. It has been estimated that up to 80 percent of all medical doctors in some European countries regularly prescribe herbal medicines. These same medicines are now gaining tremendous popularity in the United States.

As one of the early pioneers in bringing herbal medicine to America, it has been extremely gratifying to me both personally and professionally to see the use of plant-based formulas "bloom" in the United States. I remember in the mid-1980s being asked the question, "If herbs are so effective, why isn't herbal medicine more popular in the United States?" This question was raised long before the 1998 issue of *Time* magazine that featured such herbal staples like ginkgo, St. John's wort, and echinacea on its cover (an event that truly signaled the arrival of herbal medicine in America).

In the mid-1980s and before, herbal medicine was nowhere near being considered as mainstream as it is now. My answer to the question of herbal medicine's role in the United States, I now realize, was initially somewhat simplistic. I focused on economic issues, like the fact that

7

since a natural product usually couldn't be patented, drug companies preferred to develop patent-friendly synthetic substances as medicines. I soon realized, however, that the issue was much more complex.

I now think the main reason has to do with what I call the "tomato effect." What am I talking about? In the 1700s and early 1800s it was commonly believed in North America that tomatoes were poisonous, even though tomatoes had become a dietary staple in Europe. It wasn't until 1820, when Robert Gibbon Johnson ate a tomato on the courthouse steps in Salem, Indiana, that the "poisonous tomato" barrier was broken.

During most medical doctors' schooling they have been told that herbal medicines and other natural therapies don't work and that they are dangerous. There has been a tremendous bias against these sorts of "alternative" therapies in conventional medicine, but the "poisonous tomato" barrier for herbal medicines in the United States has been broken. Who broke it? I believe it was the millions of Americans who have used the products described in *Nature's Guide To Healing.* In addition, respected and knowledgeable physicians like the author of this book Gary Ross, M.D., started educating themselves on the value of herbal medicines. They began using these remedies in their practices and helped to spread the word of their beneficial effects.

A critical juncture occurred in the mid-1980s and throughout the 1990s when the tremendous results people in America experienced with high quality herbal remedies coincided with growing public concern over the safety of conventional therapies. As a general rule, herbs are less toxic then their synthetic counterparts. They produce beneficial effects with a reduced risk of side effects. Despite their growing popularity and widespread use, serious side effects due to herbal medicines are very rare and almost always signify inappropriate use. In contrast, adverse drug reactions due to taking prescription and over-the-counter medicines account for over 100,000 deaths each year in the United States. This statistic follows heart attack, cancer, and stroke as a leading cause of death.

The reason why herbs are so much safer than drugs is due to their mechanism of action, which is most often to correct an underlying cause and help the body achieve its own natural balance or what we often refer to as homeostasis. In contrast, a synthetic drug is often designed to quickly alleviate symptoms or effects without addressing the underlying cause, which then can throw the body out of balance. Throughout this book

there are numerous examples illustrating how herbs can offer a more effective and safe alternative to drugs.

Herbal medicine will certainly play a major role in the medicine of the future. There is rapidly accumulating scientific evidence to document the effectiveness of herbal medicine. In fact, during the last few decades there has been a literal explosion of scientific information concerning plants, crude plant extracts, and nutritional substances from plants as medicinal agents. *Nature's Guide To Healing* provides a valuable resource for helping you to understand, appreciate and intelligently use herbal medicine.

I truly hope you read this book carefully. I know that by doing so, it will impart its wisdom and experience to you so that you may beneficially use the healing power of herbs for yourself.

Michael T. Murray, N.D.
May 2000

Introduction to *Nature's Guide to Healing*

Twenty two years ago when I first began to practice medicine, I had no knowledge of herbal remedies. One young female patient came to see me with menstrual cramps. I prescribed some pain medication for her which was the best standard treatment at that time. The same patient returned to see me about two months later to tell me that the prescription had made her throw up. And it hadn't worked. Instead of just suffering from cramps, she also felt sick to her stomach. However, she reported that she had found an herbal formula that had worked. She told me that she had been so grateful for my effort to help her that she wanted to show me this formula which I had never seen before.

So began my gradual process of learning about herbs and other natural remedies which over the years has taken me to many seminars and to various trips to Germany and throughout other parts of the world. I also have spent countless hours over the years perusing the shelves of old fashioned health food stores, natural product supermarkets, and herb shops.

Are you on a quest for the Fountain of Youth—the mythical elixir that promises to keep your body high in energy and free of disease and death? Well, the Fountain of Youth is just that . . . a myth! If good health and longevity are your goal, start with a balanced approach to nutrition and disease prevention. An important part of this process involves familiarizing yourself with nature's herbal healers.

Good health throughout our lives is our most valuable asset. How many times have you heard family or friends express these health concerns, "I don't want arthritis to steal my joy of living. I want to be able to walk, dance, and play golf *without* pain." Or, "I don't ever want to suffer a stroke and become a burden to anyone." How about, "My family has a history of cancer; what can I do to protect myself?" Or perhaps someone has

said, "How can I get relief from chronic asthma?" Or, "There must be something to relieve the pain of varicose veins."

The investment in personal health that we make today can ensure our good health in later years. *Nature's Guide to Healing* brings to the forefront herbal formulas whose scientific evidence validates their ability to restore and support good health throughout our life span.

Too often we turn to surgery and prescription drugs to cure us of life's ills. The pages of this book offer safe and effective alternatives. In fact, any one of them could save your life or that of a loved one. You can get off the prescription drug treadmill. You can avoid costly, invasive surgery.

You're probably asking yourself, "If these herbal powerhouses are so good, why haven't I heard of them before?" Well, many of these herbs may have been forgotten over time, or they simply may not have received their due here in the United States. In some cases, your grandmother or her mother may have known about them and even used them. As drug-oriented conventional medicine and pharmaceutical companies blasted their way to an economic boom, many of nature's treasures have been overlooked and dismissed as old fashioned, allegedly lacking scientific credibility. But the facts tell us that, ultimately, this just isn't so.

NATURAL MEDICINE— A VERY WISE HEALING PATHWAY

What is the difference between *treatment* and *healing*? This is a key question for anyone who truly desires great health. Treatment, in the narrowest sense, is the application of drugs or surgery, the bringing into play of some foreign object, often alien to the body's natural ecology, to stop illness' symptoms— but from the outside, usually not getting at the root of the problem.

Of course, emergencies, such as bacterial pneumonia, require acute *treatment*. For the lengthening "marathon" of life today, however, we want to focus our attention on promoting healing. Healing stimulates the body's own natural powers and promotes a longer and healthier life. Your body, when all is said and done, is the greatest healing pharmacy. Turning on the healing powers of your own body is key to health.

Prescription and over-the-counter drugs have their place in medicine, particularly in emergency medicine and other life-threatening situations, but most often with the usual nagging health problems you will be better off working with a natural medicine that is completely safe and that initiates the healing process from within.

My goal in writing this book is to reacquaint you with these healing herbs and share the most current medical validation supporting them. As you read through this book, you'll learn how ancient civilizations across the globe relied on herbs as first-line medical therapy—and with good reason! Herbs such as astragalus and ashwaganda are mainstays of traditional Chinese and Ayurvedic systems of medicine. Khella has long been a staple of Egyptian medicine, and cat's claw of Peruvian medical practices. These herbs and others have stood the test of time. Licorice's use for stomach disorders dates back to the Sumarians and Babylonians. And of course, the powerful cancer fighter, resveratrol, comes from grapes which have been pressed and dried for centuries to support human health. If you're burdened with varicose veins, gotu kola and horse chestnut seed can restore your veins to their youthful function and appearance. From the Amazon rain forests, muira puama can help men overcome physical and psychological impotency. *Gymnema sylvestre*, from southern India's rain forests, can help diabetics lessen their need for medication. To calm a restless child, the native Americans of the American Pacific coast would give them an infusion of California poppy, a safe, non-narcotic, non-addicting extract.

In addition, I present information on several ancient herbal formulas that have only recently been rediscovered. These special formulas combine two or more herbs whose active properties complement one another for ideal treatment of specific conditions. Researchers have studied their therapeutic effects with amazing results. SinuGuard™, an upper respiratory support formula, contains the very same herbal combination that is the biggest selling product in Germany for relief of sinusitis. Phytodolor™, a formula for rheumatoid arthritis, is proven to ease arthritis pain more effectively than some steroid drugs. Uriplex™, a kidney and urinary tract support formula, has been proven to increase urinary tract health and is widely used throughout Europe. Sadly, these potent, safe individual herbs and herbal formulas haven't received much attention from the American media. Fortunately, I'll tell you where to locate these formulas and how to use them to take advantage of their healing powers.

Just because these herbs are not widely promoted in the United States, that doesn't mean the rest of the world isn't using them. Throughout Europe, Asia, and even South America these herbs are best sellers. All may be used as a first-line defense against illness and are commonly prescribed by doctors throughout the world to extend the health-

iest years of their patients' lives. No wonder, the average life span for so many other nation's peoples is so much longer than that of Americans.

Fortunately, America is experiencing a renaissance—a renewed interest in herbal medicine. A growing number of people, fed-up with habit-forming drugs and their countless side effects, are turning to herbs—also called phytomedicines—for safe and effective healing and pain relief. In response, scientists all over the world are conducting clinical studies to further validate the healing powers of these herbal medicines.

With this expanding knowledge, more precise extracts are being made available to the public each year. I am truly hopeful that this trend in herbal science will continue to offer you more founded hope and health than ever before.

The herbs and formulas listed in this book currently, or will soon, line the shelves of health food stores, natural product supermarkets, pharmacies and even doctors' offices. Look for them. They have been proven effective and are time tested.

Today, I always consider herbal remedies when I am trying to help my patients. Through this process and the daily practice of primary care medicine, I have developed a respect and a wonder for some of these herbal products which, of course, have been used for centuries in Europe and Asia before they were studied in the modern sense. Now, if you visit Switzerland, for example, the pharmacies keep whole bags of herbs on the shelves as well as herbal tinctures and creams. In recent years, there has been a push to study these herbs to determine scientifically what the active ingredients are. It is no secret that when a person takes the correct herb for a problem, there is a real beneficial effect.

The public interest in herbal and natural remedies is now very strong. In my practice I see people from many walks of life coming in looking for herbal help for high blood pressure, elevated cholesterol, depression, insomnia, indigestion and other concerns. Patients are seeking out these herbal remedies because they want safe alternatives to drugs.

HOW TO USE THIS BOOK To help you understand how you can benefit from these herbal formulas and individual herbs, I've condensed clinical research into a reader-friendly format. As you browse through this book, you will discover how to use these herbs and herbal compounds as part of your overall formula for

healthy living. I feel confident you will quickly notice marked improvements in your health in a myriad of ways.

What is so remarkable about these individual herbs and healing formulas is that their numerous healing properties can be employed in the treatment of a variety of existing conditions, or they can be used for fortification of the body's optimum state.

The herbal formulas in *Nature's Guide To Healing* are based on their long time very successful use in Europe and elsewhere in the world. Part One of this book explains about shopping for herbal products and how herbs are extracted and standardized. Part Two describes twelve terrific herbal formulas. For each herbal formula, the precise contents are given as well as a useful background to understand the purpose of the formula and how it may be used most beneficially. Part Three describes seventeen individual herbs for health. For each herb, interesting background information is given, followed by the uses and daily recommended dosages. I have also included a thorough list of references for each formula taken from books and medical and scientific journals. And after Part Two is a wonderful series of photographs of many of the herbal healers to be detailed in Part Three. Finally, in Resources, I tell you which formulas and brands I personally recommend and how to obtain them.

As you read through *Nature's Guide To Healing,* you will learn how to use these formulas and individual herbs as part of your program for rejuvenation and buoyant health. As you use this guide, you will find, as I have, that herbs offer relief and real help for people suffering from so many health concerns. It is my hope that you, your family and friends will all benefit greatly from the information presented within.

Let's get ready for a fantastic journey as we learn about these amazing herbal super healers and how their powers can help us to jump-start our own quest for super health!

With Best Regards for Great Health,
Gary S. Ross, M.D.
San Francisco, California

Safe and Healthy Herbal Preparations

*There are many truths of which
the full meaning cannot be realized until
personal experience has brought it home.*

—John Stuart Mill

Safe and Healthy Herbal Preparations

A trip to the health food store is fast becoming a mind boggling, almost mind-numbing experience. A dizzying array of products with multitudes of claims line the shelves, and consumers often struggle to find the real thing that will deliver the desired results. Often, for too many consumers, the only determining factor is price. And yet while it's true that there are often significant price disparities among brands—beware, price notwithstanding, there are also vast differences in quality.

Shoppers seek direction and why not?

Buying a safe, healthy, and effective herbal preparation ought to be easy. It isn't. Consumers have many questions about the herbs they are buying:

- Does the herb really do what its manufacturer claims?
- Is the excitement over its advertised benefits truly deserved or is it premature or marketing hype?
- Which portion (root, stem, leaves, bark) is most therapeutic?
- How much of an herb should be taken for maximum benefit?
- How long does it take for the effect to become apparent? And, is there a toxic dose?
- Does the manufacturer know how to properly prepare the herb?
- How can shoppers be sure that the herb being purchased is genuine?

To ease your purchasing headaches consider these four simple steps:

Step 1 LEARN THE LANGUAGE OF HERBAL SHOPPING

Herbalists often use terms as though they expect everyone to know what on earth they are talking about. Since these terms are often used on labels, it's important to know the *language* of herbs.

Herbs are sold in a variety of forms. Some are prepared as teas, tinctures, fluid extracts, or soft or dry solid extracts in tablets or capsules. The type of preparation you select is one important key to the results you can expect to achieve from that herb.

It is important to understand that in one form or another, most herbs are *extracted*. For example, when an herbal tea bag steeps in hot water, this is actually a type of herbal extraction process known as an *infusion*. In this case, the solvent used to extract the medicinal substances from the herb is water. Although teas are a wonderful way to enjoy the mildest benefits of an herb and are healthy, their ability to deliver an herb's documented medicinal benefits is usually quite limited.

There are also several other methods employed today for extracting the natural goodness of the herb. Learning about the various extraction techniques for preparing herbal products will help you make a proper decision for your own personal health needs.

Extraction Techniques— Defining the Terms

Tinctures

An alcohol or water/alcohol preparation. The herb is soaked in a solvent for a specific amount of time—usually several hours to days. The solution is then pressed out, yielding the tincture, and providing a dry herb strength ratio of 1:5. In plain talk, this means one part herb (in grams) for every five parts extract (in milliliters of volume).

Liquid Extracts

An alcohol or water/alcohol preparation. Other solvents such as vinegar, glycerin, or propylene glycol may be used. This technique generally produces a dry or fresh herb strength ratio of 1:2. A 1:2 liquid extract provides one part herb for every two parts liquid extract. The use of these solvents, however, may yield a very poor level of the plant's active ingredients.

U.S. Pharmacopoeia

An alcohol or water/alcohol preparation that provides a dry herb strength ratio of 1:1. This means that a U.S. Pharmacopoeia fluid extract represents a dry herb strength of one part herb for every one part extract. To accomplish this concentration, special methods and equipment are necessary, involving heat and vacuum techniques.

Solid Extract

An evaporated U.S. Pharmacopoeia fluid extract or solid extract. This extract is prepared by evaporation methods to remove all liquid and is concentrated at ratios usually 4:1 or stronger. That means it would take four times more of the crude herb to equal the amount in the extract. For example, it takes 4 pounds of fresh or dried herbs to yield 1 pound of extract.

A solid extract is produced by further concentration of the extract using the mechanisms described above for fluid extracts, as well as other techniques such as thin-layer evaporation. The solvent is completely removed, leaving a viscous soft-solid or hard-solid material—depending on the plant portion, solvent, and drying process used. The solid extract can then be ground into course granules or a fine powder.

Milligram for milligram, solid extracts, sold as capsules and tablets, are the most concentrated herbal products available.

Standardized Extracts

A standardized extract assures consumers will receive an herbal preparation whose potency is guaranteed. The term *standardized extract* or *guaranteed potency extract* refers to an extract guaranteed to contain a specific level of active compounds. Stating the content of active compounds rather than the concentration ratio allows for more accurate dosages to be made.

The Importance of Standardized Formulas

Why is standardization so critical? Some health professionals will tell you it is not. They'll tell you that when a plant is standardized you lose the *whole* effect of the plant, and they will tell you that excessive processing techniques dilute the effectiveness of the plant. *But this just isn't true.* Most of the medical studies on herbs, in fact, use standardized extracts which allow for all of the compounds in the herb to be present but with special emphasis on marker compounds to insure a reliable dosage and the best opportunity for reliable results. This is true for some of our most well-known herbal healers such as saw palmetto, St. John's wort, and black cohosh.

Standardization is a quality control process. Anyone can take an herb and bottle it and sell it as medicinal support for human ailments. But conscientious herbal manufacturers take the necessary steps to provide uniform, high-quality herbal extracts, and they document their products with scientific studies when possible.

Products containing standardized extracts are guaranteed to contain a specific level of scientifically identified, bioactive compounds from bottle to bottle and season to season. This allows more precise dosages to be delivered. "Human sensitivity to an herb could vary by eight fold," notes Rob McCaleb, president of the Herb Research Foundation. "An appropriate dose of [a nonstandardized herb] for one person could be eight times too much for someone else. Thus, it is important that herbal products be consistent from dose to dose."

Without standardization, consumers may not get what they pay for. Take the case of St. John's wort (*Hypericum perforatum*). Americans have developed an intense affection for this herb—and with good reason. Consumers no longer have to rely on prescription anti-depressants (e.g., Zoloft, Paxil, and Prozac) with their often significant complications for relief of mild to moderate depression. Clinical studies validate this herb's ability to treat mild to moderate depression, and consumers can now turn to nature's therapy and be assured long-term satisfaction.

Purchasing any brand of St. John's wort, however, may not yield expected results. St. John's wort is most effective when the product contains 0.3 percent hypericin and 4 percent hyperforin—the two chemicals in the plant that are thought to be most bioactive.

Without standardization, you have no idea how much of St. John's wort's active ingredients, hypericin and hyperforin, you are getting—or if the level is the same from one capsule to the next.

The Standardization Process

Standardization involves the following steps:

- **Proper identification of plant material** through a series of laboratory tests
- **Analysis of plant material** to assure it is free from pesticides, heavy metals, and microbiological contamination.
- **Measurement of the level of key plant compounds** and selection of only the premium plant materials with compound levels high enough to match (or exceed) the levels listed on the product label.

Standardization takes considerable time and effort. For example, to provide *Panax ginseng's* benefit at a consistent level, a manufacturer may need to evaluate 10 to 20 samples to find just one that has a high enough level of ginsenosides, ginseng's most important constituents. It's a time consuming expensive process, and that's why I often say there are no two-dollar miracles in herbal medicine!

The quality of herbs is due to many factors: variability in soil; growing conditions; harvesting techniques; and processing methods. Handling after harvest also has a huge impact on the medicinal properties of herbs. Each factor in the process is important. When herbs are collected from their natural habitat, they are said to be wildcrafted. This method is still used to make herbal medicines on a small scale. However, most herbal products today are produced from herbal crops via commercial farming techniques, due to uniformity in soil conditions, growing conditions and time saved in locating plants for harvest. Plus, we have to be careful not to exploit our naturally harvested herbs and destroy the population of wild-grown herbs to the point where none are left or the herb becomes an endangered species. Already, populations of wild echinacea, ginseng and goldenseal are critically endangered due to population encroachment and overharvesting. Wildcrafting can eventually wipe out an herb, making it obsolete. Wildcrafting should be regulated to protect the future growth of many of our most precious medicinal plants.

These combined factors provide herbal product manufacturers with quality assurance in regard to growing condition factors. In addition, cultivation is a better process because manufacturers can control growth and reproduction of the herb.

Step 2
LEARN HOW HERBS ARE GROWN AND HARVESTED

Plants go through many key processes on their way to the consumer. The first, and most important step, is to know when to harvest a plant. Most plants must be harvested at their peak time of growth to insure that a high level of the active constituent is preserved. The next step involves a number of sorting and processing treatments to prepare the plant material for its final processing step. Here are some of the most common:

Garbling is usually done by hand and refers to the process of separating the useful portion of the herb from dirt, sand, grains, and other undesirable matter. Occasionally, a garbling machine is used.

Drying herbs is another important method of handling. When harvested, herbs are very moist. They must be dried properly or they will rot. Fortunately, most herbs require fairly temperate drying conditions, which supports the retention of their medically useful constituents. Indeed, most herbs need to be kept only at about 100 to 140 degrees Fahrenheit for effective drying. At the end of the process the herb is still fairly moist, but it can be stored with a moisture content reduced to less than fourteen percent.

Step 3
LEARN ABOUT THE HANDLING OF HERBS

Juicing or pressing is used when drying a plant is counter-productive and likely to destroy heat-sensitive active ingredients.

Grinding is the means of breaking down leaves, roots, seeds, and other plant parts into a powder. A number of machines can be used to grind herbs. Some manufacturers use knife mills and teeth mills, but the most commonly used mill is a hammer mill.

Step 4
LEARN ABOUT
QUALITY
GUARANTEES

It is important to seek further validating criteria for making safe and healthy shopping choices. One very good benchmark for quality is the German Commission E, Germany's equivalent to our Food and Drug Administration (FDA). The Commission E has reviewed the historical and scientific literature on hundreds of medicinal herbs and established stringent standards for their production, manufacture, and consumer use.

In Germany, doctors are taught the use of phytomedicines as part of their medical school training. Long recognized as the world's most impartial and quality-oriented standards board for herbal medicines, the Commission E produces monographs which detail proper herbal selection for health treatments, accurate plant identification, and ideal harvesting techniques. Manufactured herbal products that meet or exceed the German Commission E are among the highest quality products available today. Look for this conforming standard, listed on the label, for products you are purchasing.

In fact, whenever possible, I'll detail the German Commission E standards for those herbs that have such a monograph. In this way you can be assured that you will receive unbiased information on how to purchase the highest quality herbs available today.

A complete set of German Commission E monographs has been translated and compiled by the American Botanical Council, a non-profit research and education organization. The book contains over 600 pages of vital herbal information, including 380 monographs, cross references, glossary, and indexes. (See Resources for information on how to obtain this valuable guide.)

Educated Shoppers Get the Best Results

It is hard to predict exactly where the herbal medicine market is headed. But one thing is for sure, you're going to need reliable information to keep up with its increasingly complex and changing environment. Take time to educate yourself about the natural medicines you or your family are using. Put purchasing power back into your own hands . . . can you afford not to?

Nature's 12 Best Healing Formulas

The art of healing comes from nature and not from the physician. Therefore, the physician must start from nature with an open mind.

—*Paracelsus*

ONE / CANKER SORE FORMULA
LongoVital®

FORMULA CONTENTS

- Pumpkin seed (*Cucurbita pepo*)
- Arnica (*Arnica montana*)
- Rosemary (*Rosmarinus officinalis*)
- Paprika (*Capsicum frutescens*)
- Milfoil (*Achillea millefolium*)
- Vitamins A, B_1 (thiamin), B_2 (riboflavin), B_3 (niacin), B_5 (pantothenic acid), B_6 (pyridoxine), C, D and E

MAJOR USES

- Canker Sores

BACKGROUND

Canker sores may seem rather benign to some folks. Sure they hurt when eating citrus or hot foods, but they come and go on their own, right? Well, that may be true for you, but, for an unfortunate few, canker sores can be a recurring condition. Imagine suffering from canker sores every month of the year! The exact cause of canker sores is uncertain; yet, we all know how painful these soft tissue sores in the mouth can be. Often occurring in clusters, their healing course usually takes from one to three weeks, with the most painful period during the first week.

Treatment for canker sores has mainly focused on pain relief with use of topical steroids. For those suffering from recurrent canker sores, interruption of the cycle of formation is necessary. As stress plays a role in this type of canker outbreak, we now believe the immune system may play an important role in their recurrence.

LongoVital®, a proprietary formula containing ground herbs and vitamins, is the first harmless, systemic treatment that has been proven beneficial in the treatment of recurrent canker sores and that is effective for pain management, inflammation, and immune system support.

**FORMULA
BREAKDOWN**

Pumpkin Seed

Pumpkin seed may seem like an unlikely ingredient in a medicinal formula. In fact, however, pumpkin seeds have long been used by Native Americans for treatment of parasites, wound healing and kidney, urinary and inflammatory disorders. The plant is native to tropical America, yet has been grown throughout North America for centuries. While the pumpkin's fruits may be most notable for their role in autumn holidays, the seeds have long been recognized as an anthelmintic or agent that kills intestinal worms or expels them from the body. In the case of LongoVital®, it is the anti-inflammatory property of pumpkin seeds that is employed to promote canker site healing.

Arnica

Arnica's common names are leopard's bane or mountain tobacco. Native to the mountainous regions of Europe and Siberia, it is also found west of the Mississippi River in the United States. An attractive plant with two inch yellow-orange flowers, arnica is poisonous if ingested copiously in very large amounts. Nevertheless, this plant has been used medicinally in Europe since the 16th Century. The powdered flower, in minute amounts, is a mainstay of homeopathic remedies for treatment of shock and injury. In the LongoVital® formula, a homeopathic level of arnica is included to treat pain and inflammation of canker sites.

Rosemary

Rosemary is best known for its culinary traits. A member of the mint family, this Mediterranean native is a fragrant, hardy perennial shrub averaging two to four feet in height. Its dark green leaves with silver undersides make it an attractive plant that is used both for landscaping as well as medicinally.

Ancient Greeks used rosemary to improve memory, hence its origin as a symbol of remembrance for brides and deceased alike. Apothecaries of the 16th and 17th centuries used it to treat intestinal gas, digestive complaints, toothaches, gout, and cough.

Rosemary's contribution to the LongoVital® formula includes its antiseptic properties, as well as its ability to encourage growth and repair of cells. Rosemary also contains high levels of easily assimilated calcium which is an essential nutrient for the nervous system.

Paprika

Found in warm regions of the Americas and some regions of Europe, paprika was first introduced to Europeans by Columbus. Paprika is actually the name of the spice ground from the sweet bonnet pepper, a member of the nightshade family. Grown as an annual in North America, it is a small, woody shrub that has been cultivated for over one-thousand years in South America. The pods, harvested late in the summer, are dried and crushed. Paprika is most popular for culinary uses, especially Hungarian paprika. But paprika also has nutritional properties that are employed in the LongoVital® formula. This member of the pepper family has exceptionally high concentrations of beta-carotene and vitamin C. Both of these nutrients are essential for immune function.

Milfoil

Milfoil, also known as yarrow, bloodworm and thousand-leaf, is a fine, feathery leafed perennial native to Europe and North America. The original species has cream colored flower heads, but today cultivars with pink and yellow flowers are popular with gardeners.

Milfoil has been used since the time of the ancient Greeks as an antiseptic to treat cuts, wounds, burns and bruises, as well as for sores and toothaches. Its name comes from the hero Achilles who is said to have given Milfoil to his soldiers to stop bleeding.

The plant has also been long used by Native Americans in much the same way as the ancient Greeks. Today, the manufacturers of LongoVital® continue this tradition, utilizing milfoil's medicinal properties to promote healing of canker sores.

Vitamins

Along with LongoVital's® herbal components are key vitamins that play an important role in its effectiveness against canker sores. These nutrients are integral to immune function and play a role in the healing process.

In particular, the formula's contingent of B vitamins makes a unique contribution to the LongoVital® formula. Vitamins B_1 and B_2 are both important contributors to normal growth and development of the body's mucous membranes. Vitamin B_3 promotes nerve and skin health. Vitamin B_5 helps wounds heal more quickly by stimulating new cell growth. And Vitamin B_6 also plays a crucial role in immune function while assisting the body in favorably responding to

stress. Meanwhile vitamins A, C, D and E also contribute to healthy immune function.

MAJOR USES
DEFINED

Canker Sores

The average person confronted with canker sore discomfort may not seek treatment, knowing it will go away in time. But for some people recurrent bouts of canker outbreaks make this a chronic oral condition with a high enough level of discomfort to seek treatment.

LongoVital® was examined in a double-blind study of 29 healthy patients who suffered from canker sores an average of 12 times a year. Those taking three tablets of LongoVital® daily experienced a significant decrease by the fourth month of participation. Thirty-one percent of the patients were totally free of recurrence over a period of one year.

The primary effectiveness of LongoVital® may be in its ability to stimulate the immune system, as shown in a study of 31 otherwise healthy patients who were suffering from canker sores. The activity of various lymphocytes (infection-fighting white blood cells) was measured in blood levels of the participants. Fourteen participants were given LongoVital® during the first six months of the study and the remaining were given LongoVital® for the last six months of the study. Both groups showed significant increases in lymphocyte activity during the period they received LongoVital®, suggesting LongoVital® is an immunostimulant that is highly effective with patients who are suffering from recurrent canker sores. It is very likely that the increase in various lymphocytes contributes to its ability to prevent further ulcerations.

SHOPPING
INFORMATION

LongoVital® is available in tablet form. See Resources for detailed purchasing information.

RECOMMENDED
DAILY DOSAGE

Three tablets taken daily are recommended for treatment of recurrent canker sores.

TOXICITY

There are no known side effects of the LongoVital® formula.

TWO / DEPRESSION FORMULA

Laif® 600
(also known as **Psychotonin®**)

FORMULA CONTENTS
- St. John's wort (*Hypericum perforatum*)

MAJOR USES
- Depressive Disorders
- Anxiety

BACKGROUND

Medical practitioners have long acknowledged that emotions play a role in health. But not until this century has so much emphasis been put on the amazing power of the mind. Today, an unprecedented number of individuals are seeking relief from depression—which can breed feelings of loneliness, boredom, helplessness, and even suicidal tendencies. Depression is real. It's a condition that has made its way into our everyday jargon and daily lives. In fact, depression ranks fourth on the list of reasons people consult a doctor.

Depression is also a big business. As Americans demand relief, pharmaceutical companies race to manufacture a magic bullet. We've been introduced to Zoloft, Paxil, Prozac, and other prescription drugs, but unfortunately their side effects often outweigh their benefits.

Ultimately, a large number of people suffering depressive disorders discontinue these prescribed treatments because of unpleasant side-effects including nausea, anxiety, insomnia, and loss of appetite. Many people also experience loss of libido—or depressed sexual response.

The good news is that natural herbal medicines can bring needed relief in a safe and effective manner. St. John's wort, an unassuming European herb now prevalent throughout North America, has proved to be extremely effec-

tive in treating mild to moderate depression. More than two dozen controlled, clinical studies have been conducted in Europe to scientifically validate this herb, and more studies are underway. Both conventional and alternative health care practitioners are excited about this herb's healing potential.

Most preparations manufactured from hypericum include a standardized dose of 0.3 percent hypericin, the active component that has proved effective in clinical trials. But in Germany, researchers have developed a proprietary process to extract more active constituents from the crude herb. Each single tablet of a product known as Laif® 600 contains higher concentrations of St. John's wort's active constituents, thereby allowing treatment of depressive disorders with one tablet daily. Laif® 600 is the result of 40 years of research and countless clinical trials. Unlike many other St. John's wort preparations, Laif® 600 offers a treatment option with optimal compliance and high efficacy.

FORMULA BREAKDOWN

St. John's Wort

St. John's wort, a native European herb with yellow flowers, was once used by 19th Century physicians for wound healing, and also as an astringent, diuretic, and mild sedative.

Only recently have this herb's full therapeutic benefits become apparent. A number of constituents are responsible for the desired effect of St. John's wort with hypericin and hyperforin apparently the herb's premiere compounds.

Scientists are not certain how these compounds exert antidepressant effects within the human body; however, the most popular theory is that St. John's wort inhibits the brain's uptake of the feel-good neurotransmitter chemical, serotonin, which allows for more of this substance to circulate in the bloodstream, affecting mood in a positive manner.

MAJOR USES DEFINED

Depressive Disorders

Over the past few years, 23 randomized and controlled studies involving patients with mild, moderate, and severe depressions were performed. In patients with mild to moderate depression, hypericum extracts were significantly superior to placebo and to standard anti-depressants. In addition, the incidence of adverse side effects was half that of synthetic anti-depressants.

In one such study, 97 patients underwent treatment with the hypericum preparation for six weeks. Patients given the formula markedly improved during therapy, and no adverse side effects were reported.

In yet another study, 88 patients with mild to moderate disorders were given 30 drops of the hypericum preparation or a placebo. The disease progress was monitored over a four-week period. Compared to the placebo, the symptoms of depression decreased very significantly after only fourteen days. The tolerance was excellent with no adverse side effects reported.

In comparing Laif® 600 with chemical anti-depressants, such studies also indicate the specific formula is highly effective. In a randomized study over four weeks, the efficacy, tolerance and pharmacodynamic profile of Laif® 600 was investigated relative to a common European antidepressive, bromazepam. The symptoms of depression significantly improved in both treatment groups. Treatment outcomes with regard to anxiety, restlessness, and psychosomatic discomforts were excellent. Also, it should be noted that the hypericum preparation improved sleep quality and prevented loss of sexual drive and performance to a higher degree than the bromazepam.

Anxiety

In a randomized, double-blind study over four weeks, the hypericum preparation was given to 20 patients with anxiety. Seventy-five percent of the patients experienced very good relief. Testing showed a significant reduction in symptoms of depression that initially had been quite pronounced. In addition, the number of patients complaining about psychophysical disturbances decreased markedly.

SHOPPING INFORMATION

Laif® 600 is available in tablet form containing 612 mg of hypericum special extract STW3, corresponding to 4 grams of crude St. John's wort. The St. John's wort in every bottle of Laif® 600 is laboratory tested to insure that the percentage of the herb's active compounds is consistent with product labeling, and that it is completely safe and natural. This formula is available only through its German manufacturer. See Resources for ordering information.

RECOMMENDED DAILY DOSAGE

Take one tablet daily until the depression, anxiety or related side effects subside. Depressive- or anxiety-related disorders can only be corrected slowly. Please allow four to eight weeks to obtain desired results, then take for several weeks or longer thereafter to insure a relapse does not occur.

TOXICITY This herbal preparation offers a high level of health benefit with a low level of risk when taken at the recommended dosage. In rare cases, Laif® 600 can increase the photosensitivity of the skin under intense sunlight. Therefore, avoid direct exposure to sunlight, and do not visit sun-tanning studios when using this product. If you are also using prescription anti-depressants it is extremely important that you consult with your physician before discontinuing medication or start taking this formula.

THREE / FEMALE RELIEF FORMULAS I AND II

Black Cohosh &
Black Cohosh Plus St. John's Wort

FORMULA CONTENTS

Black Cohosh

- Black cohosh root
 (*Cimicifuga racemosa*)

Black Cohosh Plus St. John's Wort

- Black cohosh root
 (*Cimicifuga racemosa*)
- St. John's wort
 (*Hypericum perforatum*)

MAJOR USES

Black Cohosh

- Hot flashes
- Night sweats
- Bloating
- Nervousness
- Headaches
- Heart palpitations

Black Cohosh Plus St. John's Wort

- Same indications as black cohosh
- Depression
- Anxiety

BACKGROUND

Times are definitely changing when it comes to the so-called "change of life." Once discussed in hushed tones, the mystery of menopause is unraveling as baby boomers refuse to suffer silently through this natural occurrence. Their hunger for knowledge has created an influx of discussion and debate surrounding menopause treatment options—the most notable being hormone replacement therapy (HRT) versus herbal medicine.

To dissect this debate, let's first review the physiology of menopause. Virtually all women reach menopause between their late forties through around age fifty-five. Hot flashes, weight gain, elevated blood pressure, sleep difficulties, and vaginal dryness mark the first notable side effects—all of which can be traced to hormonal changes.

Menopause actually begins when a woman's body stops producing estrogen, a hormone produced by the ovaries. Estrogen is critical for healthy development of female sex traits, regular menstrual cycles, bone growth, and cholesterol level control. In addition, menopause occurs

when leutinizing hormone (LH) and follicle-stimulating hormone (FSH) levels fluctuate.

For half a century, HRT has held a place in conventional medicine as a means to relieving undesirable side effects of menopause. HRT, a combination of estrogen and progestin, is usually prescribed to women who have not had a hysterectomy. The blend of compounds is necessary because when given alone, estrogen can increase the risk of endometrial (uterine) cancer.

For women who have had a hysterectomy, estrogen replacement therapy (ERT) is sufficient. Estrogen has been shown to alleviate hot flashes and night sweats. In many cases it even provides protection against heart disease and osteoporosis.

Sounds too good to be true? Well, it may be. Recent research links both forms of estrogen-based therapy with liver, ovarian and breast cancers besides gall bladder disease and blood clotting, to name a few complications. Also, while both therapies claim to slow bone density loss, no one knows if the duration of this effect lasts or if women must continue to use estrogen for the rest of their lives.

To offset these potential pitfalls, researchers have unveiled a new class of HRT drugs called SERMs or selective estrogen reception modulators. Scientists claim the estrogen in the new drugs (e.g., raloxifene) stimulates some tissues while inhibiting others. Thus, they claim health risks are reduced. Well, maybe. Recent research shows experimental ovarian cancers can be induced by this drug at levels approximately those used in actual therapy.

Is HRT or ERT for you? In some cases this very powerful medicine may be of benefit. But for women with pre-existing medical conditions, or those who have a high risk for breast besides other reproductive cancers, both HRT and ERT are inadvisable. What's more, women with mild to moderate menopause symptoms who don't want to commit to expensive, lifelong therapy should investigate alternative treatments.

Today's women can expect to live one-third of their lives after menopause. HRT may be a temporary fix, but in the long run it may be wiser to take control of unpleasant symptoms through adoption of a healthier lifestyle. According to the North American Menopause Society (NAMS), less than half of women eligible for HRT have taken it or are currently taking it. In fact, experts estimate that only 16 percent of women who have gone through menopause naturally now take hormones. A large percent get pre-

scriptions filled but leave the pills in the bottle. These women and others are turning to natural diet and lifestyle therapies for menopause relief—and a growing number use plants rich in phytoestrogens like soy.

Hot flashes, Night Sweats, Bloating, Nervousness, Headaches, Heart Palpitations

MAJOR USES DEFINED
Black Cohosh

There are a number of herbs such as chaste berry, dong-quai, and red clover to use for menopause, but most of these lack adequate research studies to support their effectiveness. Black cohosh, on the other hand, is a well documented herbal treatment for menopause.

In fact, in 1989 the German Commission E specifically noted that it "approves black cohosh as a non-prescription medicine for premenstrual discomfort or menopausal neurovegetative ailments."

Black cohosh seems specifically designed to combat menopause side effects without posing health risks. Since 1959, over 1.5 million menopausal women have used this herbal medicine with great success. And in 1996, nearly 10 million monthly units of this extract were sold in Germany, Australia, and the United States.

Scientists have studied the efficacy of black cohosh extract in many studies among women with menopausal complaints, who are at risk for complications with HRT, or who want a natural treatment alternative.

In one study, carried out by some 131 doctors, 629 female patients were given 40 drops twice daily of black cohosh for a period of eight weeks. Eighty percent of the participants reported a significant improvement in both physical and psychological complaints within six to eight weeks (see table).

Black Cohosh Benefits Menopausal Symptoms

SYMPTOM	% NO LONGER PRESENT	% IMPROVED	TOTAL % IMPROVED
Hot flashes	43.3%	43.3%	86.6%
Profuse perspiration	49.9%	38.6%	88.5%
Headache	45.7%	36.2%	81.9%
Vertigo	51.6%	35.2%	86.8%
Heart palpitations	54.6%	35.2%	90.4%
Ringing in the ears	54.8%	38.1%	92.9%
Nervousness/irritability	42.4%	43.2%	85.6%
Sleep disturbances	46.1%	30.7%	76.8%
Depressive moods	46.0%	36.5%	82.5%

Source: Stolze, H; Gyne, 1982; 1: 14-16.

The authors concluded that "the herbal extract is ideal in cases of contraindication to hormonal therapy, is a promising therapeutic regime in cases of refusal of hormonal therapy, possesses high therapeutic efficacy, shows outstanding tolerance, leads to very good patient compliance, and shows positive results without the use of hormones."

Studies have also compared black cohosh extract to estrogen and diazepam In one study of 60 patients, group 1 received black cohosh; group 2 received 0.625 mg conjugated estrogens (Premarin); and group 3 received 2 mg diazepam (Valium). All three groups reported a positive influence on menopausal symptoms such as hot flashes, night sweats, nervousness, headaches, and heart palpitations. According to the authors, "the herbal treatment allows the most risk-poor therapy with optimal effectiveness in comparison to hormones and psychopharmaceuticals, demonstrates a remarkable spectrum of action on the menopausal syndrome, has no toxic side effects, is suitable for long-term therapy, and is the medication of choice in cases of mild-to-moderate menopausal ailments."

In another study, 80 patients were treated for 12 weeks. Thirty were given black cohosh, Premarin (0.625 mg daily) or placebo. Test results showed that black cohosh is suitable as the natural medicine of first choice to treat menopausal symptoms—particularly if HRT is contraindicated or not desired by a patient. Specifically, hot flashes experienced each day dropped from an average of five to less than one in the black cohosh group. In comparison, the estrogen group dropped from only 5 to only 3.5. The formula also had a positive rejuvenatory effect on the womens' vaginal tissues.

Scientists have also studied the practicality of switching from a testosterone hormone treatment to black cohosh. Fifty patients who had participated in testosterone hormone treatment because of menopausal complaints were given black cohosh for six months. Twenty-eight required no further hormone injections during the trial, 21 patients needed one injection during this time, and one patient needed two injections. The author of the study concluded, "black cohosh maintained a positive therapeutic response."

Black Cohosh Plus St. John's Wort

As indicated earlier, menopause can strike in varied degrees, depending upon a women's health, genetic makeup, age, and environmental stress. Some women glide through this time without disruption to their emotional and physical health. Others are not so lucky. For them,

menopause brings not only hot flashes and headaches, but also loss of libido, sleep difficulties, depression, and sometimes debilitating anxiety. To combat this, scientists have found the herbal combination of black cohosh and St. John's wort provides nutritional support for menopause as well as emotional well-being. While various constituents of black cohosh work to balance fluctuating hormonal levels, St. John's wort appears to balance neurotransmitter levels. As estrogen levels decline, neurotransmitter levels, particularly serotonin, also decline. Low levels of serotonin have been associated with the cause and manifestation of depressive symptoms.

In the black cohosh plus St. John's wort formula, it appears the St. John's wort extract and black cohosh extract work synergistically, thus leading to better or higher efficacy than the single compounds alone.

In 1997, scientists ran a 12-week clinical trial to assess the efficacy of such a formula. A total of 886 patients suffering from irritability, inner agitation, inability to concentrate, dejection, anxiety, sleeplessness, and hot flashes were evaluated. The results were dramatic. At the beginning of the treatment, the severity of psychological symptoms ranged from "mild" to "moderate." After a twelve-week observation all symptoms had significantly improved; the complaints were either "not present any-more" or "mild." Seventy-seven percent of women reported an improve-ment in hot flashes, 75 percent reported improvement in dejection, and 72 percent noticed an improvement in sleep patterns. Gynecologists reported marked improvement in patient symptoms. More than 92 per-cent of the doctors confirmed the efficacy of the compound and 81 per-cent of them believed that the new formula demonstrated good to very good efficacy.

Further studies are planned for this formula and will be available to the public in the coming year. In the meantime, the authors of the latest study conclude that the physical and psychological symptoms of menopause can be effectively treated with the combination treatment of black cohosh and St. John's wort. As stated by them, "Since in numerous women temporary depressive moods deteriorate the quality of life during menopause, a combined therapy is useful. The synergistic effect of two medicinal plants observed in this clinical trial is in favor of this pharma-ceutical combination."

SHOPPING INFORMATION

As noted above, black cohosh and black cohosh plus St. John's wort are very different in their metabolic function and are designed for specific women's needs.

To receive the same results as the clinical trials it is important to purchase a standardized product that matches that which was used in the trials. Your black cohosh formula should be standardized for triterpene glycosides (calculated as 27-deoxyactein). It should be used to counteract physical symptoms of menopause, including hot flashes, mood swings, night sweats, bloating, heart palpitations, and headaches.

Black cohosh plus St. John's wort should be standardized for 1 mg of triterpene glycosides content and 250 to 300 mcg of hypericin. Use this combination when menopause symptoms manifest themselves in an emotional manner, such as nervousness, irritability, depression and mood swings. Black cohosh and St. John's wort may be purchased together in a single pill or purchased separately.

RECOMMENDED DAILY DOSAGE

Take one tablet of either black cohosh formula daily. Take one to three capsules of St. John's wort daily, depending on your response, if purchased separately.

TOXICITY

Both formulas are extremely well tolerated when used as directed.

FOUR / GALLBLADDER DISEASE FORMULA
Rowalchol®

FORMULA CONTENTS
- Plant terpenes derived from purified essential plant oils

menthol	borneol
pinene	camphene
mentheone	cineol

- Olive oil

MAJOR USES
- Gallstones

BACKGROUND

The gallbladder is a small, muscular sac that plays an integral role in the digestive process. Connected to the small intestines and the liver by small ducts, the gallbladder serves as a storage chamber for bile produced by the liver and required by the small intestines in the digestion of fats and certain vitamins. Bile is also responsible for the elimination of waste products, namely cholesterol. The link between cholesterol and the gallbladder has long been understood by physicians. The Greek origin of the word cholesterol means bile solid, so called because the substance was first found in gallstones.

Cholesterol is highly insoluble in water and requires bile to break it down. Some people's bile fluids are more easily saturated by cholesterol, causing the bile to solidify and form into stones. Over 15 million people in the U.S. have gallstones, and for nearly 500,000 of these people this condition may require hospitalization. Gallstones more frequently occur among women, and their incidence increases with both age and excess weight.

Once formed, gallstones can migrate into the ducts and inhibit the flow of bile for digestion. For some, the presence of gallstones goes unnoticed, but others experience an ever present pain upon digestion, including severe colic, diarrhea, and vomiting. Gallstones lodged in the bile ducts

41

can cause inflammation of the gallbladder, interrupt proper liver function leading to jaundice, and even require surgical removal of the gallbladder. This is the most common abdominal surgery among adults in America.

Rowachol®, a proprietary formula available throughout Europe for the past 34 years, has been widely researched for the treatment of gallstones, both as a single therapy and in conjunction with conventional medications. Comprised of six plant terpenes extracted from purified essential oils dissolved in olive oil, Rowachol® has demonstrated excellent results in clinical trials for gallstone dissolution.

MAJOR USES DEFINED

Gallstones

Rowachol's® ability to alter the cholesterol levels of bile fluids has been researched extensively to better understand the relationship between controlling bile cholesterol levels and dissolution of existing gallstones. A 1985 study of healthy males without gallbladder complications examined Rowachol's® effect on bile production and bile cholesterol levels. The subjects were given 200 mg daily for four weeks. Bile acid output was increased without interference of healthy liver function and digestion, while fat levels in the bile were significantly reduced.

Conventional treatment for gallstones aims to dissolve existing gallstones through the reduction of cholesterol saturation levels of the bile. Gallstones gradually are reduced in size and have been known to dissolve altogether, but this therapy can take up to four years. Rowachol's® performance as an adjunct therapy to existing treatments has been shown to actually accelerate the speed of dissolution. In 1984, 30 patients with gallstones were treated with Rowachol® in conjunction with pharmaceutical bile acids. Stones completely disappeared in 11 patients within the first year, and in the second year 15 more patients' stones dissolved.

For some individuals, the effects of gallstones have such a damaging inflammatory effect on the ducts and gallbladder, surgery is required. In some cases gallstones can be retained after surgery and continuation of gallstone development is a concern.

Rowachol® offers an alternative to follow-up surgery. In one study of 15 such patients, a maintenance dose of Rowachol, was given daily for a year. Of these, 13 had complete dissolution of their stones within the year. One patient was withdrawn for surgery and one died during the year due to unrelated causes.

Researchers have examined the synergistic effect of plant terpenes and bile acid medication and time and again have found the plant terpenes contained in Rowachol® to reduce the tendency of bile to form into solids, as well as to help dissolve existing gallstones. This property of Rowachol® may make it useful in preventative therapies as well. One such study examined Rowachol®'s ability to inhibit the formation of cholesterol gallstones. Forty-nine patients referred for elective gallbladder surgery were given either no treatment, a low dose of Rowachol®, or high doses prior to surgery. Bile samples gathered during surgery were examined for cholesterol crystals and cholesterol composition. The mechanism by which Rowachol® inhibited formation of cholesterol crystals was not clear, but the results of this study found the those who received the Rowachol® treatment had significantly reduced levels of cholesterol content in the bile fluid, whereas cholesterol crystals were present in all non-treated patients.

Due to Rowachol®'s relatively low cost and absence of side-effects, it may well be the treatment of the future for both those at high risk of forming gallstones, as well as those who have undergone conventional treatment.

WHAT TO LOOK FOR

At this time Rowachol® is not available in the United States. However, the proprietary formula may be released for wider distribution, including in this country. (See Resources for a source outside the United States.)

RECOMMENDED DAILY DOSAGE

Take two to three capsules three times daily.

TOXICITY

This formula is free from side-effects and is known to be safe even when given over prolonged periods. Throughout all trials, no adverse effects on liver function were reported.

FIVE / GASTROINTESTINAL DISEASE FORMULA

Iberogast™

FORMULA CONTENTS

- Clown's Mustard (*Iberis amara*)
- Angelica Root (*Angelicae radix*)
- Matricaria flower (*Matricaria chamomile*)
- Caraway Fruit (*Carum carvi*)
- St. Mary's Thistle (*Silybum marianum*)
- Melissa Balm (*Melissa officinalis*)
- Peppermint (*Metha piperita*)
- Celedine (*Chelidonium majus*)
- Licorice Root (*Glycyrrhiza glabra*)

MAJOR USES

- Functional gastrointestinal diseases
- Gastrointestinal disorders due to daily prescribed medication

BACKGROUND

The performance of the gastrointestinal tract has a huge impact on overall health and well-being. In fact, it is responsible for digestion and absorption of nutrients, absorption of fluids, and removal of waste. Poor diet, emotional stress, physical conditions, and medically related drug use can compromise the vital systems involved in digestion, and lead to functional gastrointestinal diseases such as non-ulcer dyspepsia and irritable bowel syndrome. Gastrointestinal disease usually includes symptoms such as pressure and pain in the upper abdomen, feelings of fullness, lack of appetite, heartburn, nausea, constipation, diarrhea, and irregular emptying of the bowels.

These unpleasant symptoms lead American consumers to spend millions of dollars annually on over-the-counter and prescription medications. Fortunately, through years of study and application, a wonderful herbal formula has been developed for the treatment of gastrointestinal disease.

In 1968 German scientists introduced the proprietary formula Iberogast™ to the medical community and consumers. This formula is now available in the United States.

Iberogast™ has proved itself highly effective in the treatment of functional gastrointestinal conditions, gastritis, and irritable bowel disease. In addition, Iberogast™ has been found particularly useful in patients whose gastric upset is caused by medically necessary medications.

Clown's Mustard

FORMULA BREAKDOWN

The medicinal quality of clown's mustard, or candytuft, can be attributed to its active components, including glycosides and flavonoids. The extract prepared from the plant has a positive effect on the gastrointestinal tract and peristaltic action of the intestines. Clown's mustard has a long history, dating back to the Romans who used this herb to treat gastrointestinal complications.

Angelica Root

Angelica contains numerous active substances that have been employed throughout history in the treatment of a variety of conditions, including digestive ailments.

The roots and leaves of angelica are harvested for their medicinal qualities, while the stems and seeds have been used throughout history in flavorings. Angelica's roots are poisonous when fresh, but the drying process eliminates their toxic properties.

Angelica's essential oils, amaroids, flavonoids and cumarins all contribute to healing gastrointestinal complaints. They have a relaxing effect upon the digestive and intestinal tract. In addition they promote gastric secretion which aids in optimal digestive processes.

Matricaria Flower

Matricaria flower or German chamomile, is a known "cure all" that has been used through the ages. It is best known for its ability to stimulate digestion and promote relaxation. Bisabolol, chamomile's antispasmodic component, has a relaxing effect on the smooth muscle lining of the digestive tract. Chamomile also depresses the nervous system, soothes nervous upset and promotes a tranquilizing effect.

Caraway Fruit

Caraway fruit is an herb with an ancient history of medicinal uses dating to ancient Arabic culture, having spread to Europe and continuing today. While at one time caraway may have been considered a love potion to keep those close to heart from straying far from home, its most common use today and across all cultures throughout history has been in the treatment of digestive ailments.

An oil produced from the fruit contains carvol and carvene which have a relaxing effect on smooth muscles lining the digestive tract. Caraway is one of the strongest agents used to reduce colic and flatulence. It is also an essential ingredient in various digestive liqueurs and tonics throughout Europe for post-meal digestion.

St. Mary's Thistle

St. Mary's thistle is useful in the treatment of digestive complaints, bringing relief to tension in the abdomen associated with gastric upset. It is also known as milk thistle (see pages 134-137).

Melissa Balm

Long cultivated in Europe, especially along the Mediterranean, and in North America as a culinary and medicinal herb, melissa balm has valuable properties that can help to ease gas and colic. The active compounds in balm leaves—essential oils, lamiaceen, tannins, triterpenic acids, amoroids and flavonoids—have a calming effect on the entire digestive system.

Peppermint Leaf

Peppermint leaf is likely the best known herbal digestive aid. Long used in the treatment of nausea, bowel problems, and gas, peppermint aids digestion like no other herbal medicine. It has numerous medicinal properties, and it contains one of the most widely used volatile oils in culinary and medicinal practices. The essential oil enhances digestion through a number of activities. It is one of the most powerful antispasmodic agents bringing relief to the gastrointestinal tract by soothing smooth muscle tissue and reducing cramping. It also has a mild anesthetic effect on gastric mucous membranes. Peppermint oil removes gas which can form in the digestive process. One of the unique activities of peppermint in the digestive tract is its ability to stimulate gall bladder activity, increasing bile secretion. And not to be left on the sideline are peppermint's antiseptic properties. The herb also acts as an anti-fermentative agent within the gastrointestinal tract.

Celandine

Celandine, a common plant native to Europe, has been used for healing purposes throughout history. The plant contains chelidonine, a powerful alkaloid that relieves muscle spasms and cramping in the upper digestive tract, including the gallbladder. Chelidonine also stimulates the production of bile in the liver. The anti-inflammatory properties of chelidonine contribute to its overall effectiveness in the treatment of digestive disorders.

Licorice Root

Licorice has been used successfully for decades in the treatment of gastrointestinal diseases. Along with its healing qualities in the treatment of ulcers, licorice offers non-ulcer digestive sufferers relief as well. Its antispasmodic properties relax the smooth muscle tissue of the gastrointestinal tract, as well as reduce inflammation. Between 1980 and 1996, thirteen clinical studies were carried out to confirm this herb's healing powers.

Functional Gastrointestinal Diseases

MAJOR USES DEFINED

Disturbances of the gastrointestinal tract can range from mild discomfort to conditions that require hospitalization. Clinical trials of Iberogast™ were run in a variety of settings with patients suffering from gastrointestinal complaints, including a comparative study with other available medication for such complaints.

A double blind, comparative study of 77 patients over a two-week period found Iberogast™ more tolerable than the other drug used in the treatment of gastrointestinal disturbance. While both treatments performed equally on the relief of symptoms, patient compliance was higher with the use of Iberogast™ due to its more tolerable nature.

In another clinical trial, 21 hospitalized patients, admitted for different functional and organic gastroenterological diseases, were given Iberogast™. Thanks to therapy with this herbal formula, all symptoms were practically eliminated in just one week! Use of Iberogast™ continued after symptoms were arrested, and participants in this open clinical trial did not experience any recurrence whatsoever.

Additional hospitalized patient trials have been conducted. Twenty hospitalized patients suffering from functional gastric disorders found extensive and long lasting improvement in their condition after only two weeks of treatment.

The effect of this amazing herbal therapy was confirmed through diagnostic procedures in another trial of 15 hospitalized patients suffering from gastrointestinal tract disturbances. The success of treatment was classified as good to very good with no side effects.

Across the board, the verdict is positive on Iberogast™. Given its rapid onset of relief, palatable nature, and absence of side effects Iberogast™ has a promising future.

Gastrointestinal Disorders
Due To Daily Prescribed Medication

Conventional medicine for rheumatic ailments often involves nonsteroidal anti-inflammatory drugs (NSAIDs). Unfortunately, use of NSAIDs often produces undesirable side effects, particularly with regard to the digestive tract. Studies have shown that NSAIDs can lead to ulcers as well as dyspepsia and other gastrointestinal complaints. Annually, more than 15,000 deaths and 100,000 cases of hospitalizations are registered in the United States in connection with NSAID-associated ailments. What's more, recent studies show that in 1992, medical costs as a consequence of gastrointestinal NSAID side effects were estimated at over four-billion dollars.

Fortunately, Iberogast™ can help. As German researchers state, "The use of this formula is suitable for positively influencing NSAID side effects."

In one study all 20 patients (between 18-69 years old) who used Iberogast™ were practically free of gastrointestinal disturbances they experienced due to cardiovascular drugs or platelet aggregation inhibitors. In the first seven days of the two-week trial, patients reported improvements such as reduction in pressure and pain in the upper abdomen, relief of heart burn, belching, feeling of fullness and improved appetite. After fourteen days of therapy, all patients were practically free of complaints.

The same basic study was conducted with another 40 patients. Those who received the therapy reported an improvement in symptoms and increased tolerance of the basic medication.

Increased tolerance for medication is a promising effect of Iberogast™ that has been confirmed by study participants in other clinical trials. Two such trials, one conducted on 25 patients in a hospital setting and the other on 20 patients with moderate to severe accompanying diseases, found a marked decrease in complaints ranging from vomiting, nausea, diarrhea,

and gastric reflux. The first found results after only one week of treatment. The second trial, which ran for two weeks, also found complete cessation of gastrointestinal complaints. Tolerance was assessed as excellent.

WHAT TO LOOK FOR

Iberogast™ is prepared as a tincture. Its primary ingredient is clown's mustard. When you purchase it, you may notice signs of flocculation or turbidity. This has no influence on the quality of the preparation. Always check the expiration date when purchasing Iberogast™, as it should not be used beyond its shelf life.

RECOMMENDED DAILY DOSAGE

Adults may take 20 drops with warm water three times a day before, with or after meals. Children may take 10 drops three times a day before, with or after meals.

TOXICITY

Iberogast™ offers a high level of health benefit with a low level of risk.

SIX / HERPES SIMPLEX VIRUS FORMULA

Lomaherpan®/ Herpilyn® Cream

FORMULA CONTENTS
- Melissa balm (*Melissa officinalis* [70:1 extract])

MAJOR USES
- Herpes Simplex I
- Herpes Simplex II

BACKGROUND

"Lingering damage" is the definition of the Greek word herpes—and rightly so. Unlike most viruses that respond to antibiotic treatment, herpes is a lifelong condition with intermittent outbreaks, often due to the body's inability to produce an immunity to the disease. Science is also unable to offer an effective immunization. According to the World Health Organization, approximately 80 percent of all people have at one point been infected with the highly contagious herpes virus.

For many, the first infection generally goes unnoticed and then the body is able to keep the virus in check. But for some, subsequent infections' symptoms include skin irritation, itching, burning, and blister formation. An inflammation causes closely clustered blisters that eventually flow together. The clear content of the blisters becomes turbid, and the blisters dry out. They then turn to brown flakes that fall off after a few days and generally leave no scars.

The most common herpes virus is herpes simplex virus I (HSV I) which affects the face and mouth. Herpes simplex virus II (HSV II) causes blisters on the genitals, thighs, and buttocks. Herpes zoster virus is a more rare form of the disease, causing chicken pox mainly in children and occasionally in adults. Sometimes painful shingles can develop as a result of the latest herpes zoster virus.

Once exposed, an individual's main concern becomes management of the viral outbreak. Several factors contribute to a flare-up of the disease. Injury, exposure to intense sun, mental and physical stress, menstruation, or a weakened immune system can cause the appearance of a blister.

Due to its highly contagious manner, HSV must be treated quickly and effectively. It is critical to prevent the spread of the infection throughout the body. Individuals must take immediate action to prevent cell damage. The herpes virus does not disappear after an infection but simply retreats into nerve cells. Yet, while cells that have been damaged cannot be saved, non-infected cells must be protected.

Studies have shown that the healing process, reduction in the healing period, and relief from discomfort, itching, and skin tension is proportionate to the early application of treatment. Conventional treatment includes topical creams consisting of nucleoside derivatives. Studies show these analogues may produce side effects. For instance, nucleosides may induce herpes simplex virus to become resistant by modulating the metabolism of virus-infected cells, actually increasing their invincibility. Also, the recurrence-free period may become shortened.

In Europe, herpes sufferers rely on a herbal preparation to treat herpes infections that is called Lomaherpan®, a specially prepared cream made from dried extract of melissa leaves.

Melissa Balm

FORMULA BREAKDOWN

Melissa, or lemon balm as it is commonly referred to, has played a role as a curative herb since ancient times. Around 50 A.D. to 80 A.D., melissa was mentioned in the *Materia Medica* as an external treatment for insect bites and an internal treatment for abdominal colic and uterine spasms. Modern phytotherapy has discovered a new indication of its use in the treatment of herpes simplex virus.

Herpes Simplex Virus I and II

MAJOR USES DEFINED

In 1983, Lomaherpan® was launched in Germany as a natural therapy for herpes simplex virus. Research found that the melissa leaves in Lomaherpan® hindered dissemination of the infection to healthy cells by blocking host cells from spreading and inhibiting virus receptors. Lomaherpan® has been proven to markedly shorten the healing period while markedly prolonging the symptom-free interval of recurrences.

What's more, it is comforting to know that Lomaherpan® is effective in therapeutic resistant-patients where it shows rapid onset of effect.

In one study, 115 patients were given the Lomaherpan® cream, containing one percent dried melissa extract from melissa leaves. Each patient applied the drug five times a day until the blisters were healed, but not beyond a fourteen-day maximum. Clinical symptoms were recorded at days zero, four, six, and eight. In ninety-six percent of patients complete healing occurred by the eighth day of treatment. Sixty percent were healed by day four and eighty-seven percent by day six. In addition, in sixty-nine percent of patients, treatment with Lomaherpan® led to longer illness-free periods.

In a double-blind, placebo-controlled study, 58 patients were treated with Lomaherpan and 58 with a placebo. After just two days of treatment, the Lomaherpan group showed a decrease in redness and swelling, as well as a reduction in pain. Researchers concluded that, "Lomaherpan® cream is very suitable for topical treatment of herpes. Particularly noticeable is the accelerated healing process, particularly in the first days of treatment, i.e., in comparison with the placebo. The effectiveness increases dramatically when treatment begins early."

WHAT TO LOOK FOR

Lomaherpan® is manufactured from a special extraction and purification method. Because of these manufacturing methods and the extremely concentrated preparation used in the final product, other melissa balm preparations may not be as effective in treating herpes simplex virus. Until recently, Lomaherpan® was sold exclusively in Europe. Now, United States consumers can purchase this highly effective herbal preparation under the trade name Herpilyn®. (See Resources for information on how to obtain this product.)

RECOMMENDED DAILY DOSAGE

Apply a thin layer over the infected area. Use as frequently as needed. According to the manufacturer, Lomaherpan®/Herpilyn® therapy should be carried out three to four times daily to obtain a high concentration of the effective substance and encapsulate all healthy cells within the protective substance. The immediate area surrounding the diseased region should also be treated. Treatment should be carried out between four to eight days. To insure success, continue the application for a few more days after the relief of discomfort.

TOXICITY

No contraindications or toxicity have been reported.

Echinacea/Thuja/Baptisia

FORMULA CONTENTS

- Wild indigo root (*Baptisia tinctoriae*)
- Purple coneflower root
 (*Echinacea Purpureae Radix / Echinacea Pallidae Radix*)
- White cedar leaf (*Thuja Occidentalis Herba*)

MAJOR USES

- Temporary immunodeficiency with recurring infections
- Colds and Influenza
- Herpes Simplex II
- Immune support during chemotherapy or radiation

BACKGROUND

The immune system is an amazingly intricate defense network. When the network is in harmony our health is superior. In such a state we can carry out the simplest of tasks to the most difficult with ease. But when foreign substances wage an attack on our immune system, the results can be tragically debilitating. Most of the time, we are rescued from catastrophe when our white blood cells, the front line defenders, kick into action to restore our good health. Sometimes they succeed, other times they don't. Meanwhile this first line response system uses up every bit of energy we've got.

When our body's defenses are not optimal, we may come down with a nasty cold or flu. Or we may develop an autoimmune malady like rheumatoid arthritis, Crohn's disease or lupus. For persons battling cancer or who are HIV positive, immune issues become a matter of life and death.

Conventional medicine has made grand attempts and has spent billions of dollars researching immune-compromised illnesses. Yet, the battle to boost immune health continues to be fought fully unabated:

- An estimated twenty-five to fifty percent of Americans suffer from allergies.

- More than 2.5 million Americans are currently being treated for cancer and another 1.3 million are newly diagnosed each year.
- Many childhood infections, once effectively treated with antibiotics, have now become resistant to prescription drug therapy.
- Environmental immune toxins such as pesticides, industrial chemicals and other forms of environmental contamination continue to make their way into our everyday lives.

The good news is that we have the ability to boost our immune health. Research indicates that proper lifestyle choices and supplementation can influence the quality of our lives.

In Germany, researchers have developed a unique formula for immune health, which is derived from four key sources: baptisia, two species of echinacea (*Echinacea Pallida* and *Echinacea Purpurea*), and thuja. This formula is now available in the United States at health food stores and natural product supermarkets.

In countless studies, the combination of these herbs has been proven to prevent, or shorten the duration of, viral and bacterial infections; boost immune health to reduce recurrent infections; and balance white blood cell counts during radiation or chemotherapy.

What's more, studies show the combination of these particular herbs is more effective than echinacea alone.

MAJOR USES DEFINED

Temporary Immunodeficiency with Recurring Infections

A child's immune system does not mature until around the age of 11. Therefore, when pathogens attack, a young child has greater difficulty winning the battle. The result for many children is frequent and recurrent infections, especially of the upper respiratory system.

Conventional medicine has long used antibiotics to treat bacterial infections. But studies have shown that antibiotics are being over prescribed and that they can have adverse effects, prolonging an illness or increasing the chance of further infection. The rampant, improper use of antibiotics also is generating a whole new breed of bacteria that are antibiotic resistant.

For many illnesses, phytomedicines offer a responsible and effective treatment option. However, this combination formula, in particular, markedly

reduces the frequency of infection and supports the immune system during antibiotic treatment. Specifically, this formula's curative action is threefold. First, it can increase specific cell-to-cell communications by inducing greater activity of T-4 helper cells and enhancing production of interleukin-2 which also facilitates cell-cell communication. Second, it increases resistance by stimulating white blood cells' production of antibodies which attach to and disable bacterial and viral invaders. Third, the herbal formula can increase nonspecific cellular resistance, which means it enhances the overall activity of the immune system.

Colds and Influenza

It is estimated that adults suffer from a respiratory infection an average of six times a year. The result of this is not only devastating for one's personal life, but also for the economy. Lost work days and productivity are an unfortunate byproduct of both colds and flu. To speed recovery, many people throughout Europe turn to the echinacea–thuja–baptisia formula. Treatment helps them overcome infections within a shorter period of time and reduces the risk of suffering a secondary bacterial infection.

In one double-blind study of patients with viral, feverish respiratory tract infections, 50 patients were treated either with our immune formula or placebo. After three days, patients treated with the immune formula showed a significant improvement in all major symptoms in comparison with those treated with the placebo.

Herpes Simplex II

Herpes is often called a "disease for life," as this virus tends to hide in nerve cells where the immune system cannot find it and, therefore, cannot eradicate it. The herpes simplex virus causes cold sores on the lips and in the mouth and in the case of some strains can settle in the genitals. One characteristic of herpes simplex is that it tends to recur at the same site and often manifests itself during times of stress, infection, or local deficiencies in the immune system.

In one controlled study, among patients who received our immune formula, the length of time to cure the herpes was an average of 6.8 days. Without treatment, the herpes outbreak remained for ten to eleven days.

Immune Support During Chemotherapy And Radiation

"Most medical treatments, like chemotherapy and radiation are serious immune depressants," notes Dr. Patrick Quillin, one of America's leading

experts on nutrition and cancer. "These therapies induce a loss of appetite which further depresses the immune system with malnutrition."

In another key study, the medical faculty of Hanover enrolled 70 advanced breast cancer patients who were being treated simultaneously with a combination of radiation and chemotherapy for twelve months. Thirty-five received chemotherapy plus the immune formula and thirty-five, placebo. Study results showed that the immune formula has a protective effect on bone marrow in response to the toxic effects of combined chemotherapy and radiation.

WHAT TO LOOK FOR

This blend of herbs can be found in tablet form. The tablet should contain 2 mg of thuja, 7.5 mg of echinacea, and 10 mg of baptisia. (See Resources for information on how to obtain this formula in the United States.)

RECOMMENDED DAILY DOSAGE

This formula may be used daily for prevention, as well as for treatment. For prevention, adults may take three tablets three times a day. School age children should take one tablet three times a day. Take for ten to fourteen days through a cold or flu and beyond.

TOXICITY

No side effects have been reported.

EIGHT / INFLUENZA FORMULA

Sambucol® Lozenges

FORMULA CONTENTS
- Black Elderberry (*Sambucus nigra*)
- Raspberry (*Rubus idaens*)

MAJOR USE
- Influenza

BACKGROUND

Each year along with the autumn leaves comes the cold and flu season. While most of us may consider these illnesses routine and expected interruptions to our general good health, those who have chronic health conditions can find these seemingly simple viruses a constant threat to their well-being.

Millions of Americans suffer from the common cold throughout the year, so much so that it is the leading cause of absenteeism in our workforce. Influenza viruses, the more glamorous members of the viral family, are responsible for epidemics throughout human history. One such outbreak in 1918 killed over one-half million Americans due to complications in vulnerable children and adults from secondary infections such as bacterial pneumonia.

Despite their common occurrence, viral infections remain a major challenge to medical researchers. On their own, viruses are harmless. However, once inside of a living cell, they begin to replicate.

While a cure for the common cold still eludes researchers, we have come to better understand the function of our immune system due to extensive research on the life cycle of viruses. It is ironic that with all of the attention focused on technology's role in intervention, researchers

have overlooked tried and true natural remedies such as the elderberry, which has been used in treatment of colds and flu for over 2500 years.

Most recently, immunologists began researching elderberries in Switzerland under the supervision of Dr. Jean Linderman, the researcher who discovered interferon, one of the immune system's key virus-fighting protein molecules. While researching the active ingredients of elderberries, she and her colleagues found the proteins in elderberry also inhibit viruses by interfering with the enzyme they rely on to break down cell walls, thereby blocking the virus' entry into cells and its ability to replicate.

Over time, Dr. Linderman and others continued their research at the Hebrew University-Hadassah Medical School in Jerusalem, Israel, further examining elderberry's antiviral properties. After leaving the Hebrew University in October 1996, the researchers started their own company, Razei Bar, wherein they developed the proprietary—and, I might add, legendary—Sambucol® formula.

FORMULA BREAKDOWN

Black Elderberry

It is black elderberry that possesses legendary healing properties. The fruits of this plant have been gathered for their nutritive value since the time of early Egyptian civilizations. Elderberry wine and tinctures are a mainstay of the European medicine chest; throughout the world, the gathering of these berries has been a seasonal tradition for generations.

Elderberry trees can be found throughout Europe, North Africa and Israel. They grow in small hedges and bear clusters of purple-black berries in autumn.

Raspberry

Raspberry, better known for its flavorful fruits than its medicinal properties, is native to Europe and has been naturalized throughout North America. This perennial shrub grows in thickets near roadsides and woodland edges. The leaves, bark and fruit all contain medicinally useful components. Native Americans and early European herbalists alike have used raspberry for its astringent, antispasmodic, and relaxant properties.

Influenza

The power of Sambucol® to inhibit influenza viruses was studied in a placebo-controlled study in Israel. During an outbreak of influenza B (Panama strain) in an agricultural community, participants were immediately given Sambucol®. Symptoms of fever decreased markedly while overall well-being showed significant improvement within two days for 93 percent of the participants receiving Sambucol®. Those receiving the placebo reported an improvement in six days. The duration of the illness was also markedly shortened among those persons using the formula. Researchers also studied the levels of antibodies found in serum taken from study participants. Persons who received Sambucol® had developed much higher levels of antibodies to the influenza B virus.

Sambucol's® effectiveness has also been tested on numerous strains of influenza viruses *in vitro* (in the test tube). In these studies Sambucol® inhibited the replication of a wide variety of human influenza viruses including: type A/Shangdong; A/Beijing; A/Texas; A/Singapore; type B/Panama; and B/Yamagata; as well as various animal strains of the virus. In light of viruses ability to move between host species and mutate, this level of antiviral activity is extraordinary.

In 1995, the Congress of Microbiology heard findings on Sambucol's® incredible *in vitro* antiviral activity in regard to type A and B strains of influenza, herpes simplex virus I, and HIV. With regard to the HIV research, infected cells were pre-incubated with Sambucol®, then added to noninfected cells. A significant reduction in infectivity of HIV was found, in comparison with non-treated infected cells. Indeed, HIV antigens were not detected for up to five and nine days after initial exposure. Researchers consider these findings promising and research continues on the use of Sambucol® with HIV-exposed individuals.

Several elderberry products for colds and flu are on the market in the United States. Variations in formulas arise due to Sambucol's proprietary nature. Some products contain more sweeteners, others additional vitamins and minerals. Liquid extract formulas and lozenges are the two forms manufactured. (See Resources for my recommended formula.)

**RECOMMENDED
DAILY DOSAGE**

Lozenges

For treatment of influenza and colds, take four lozenges daily at the onset of symptoms. For long-term treatment to enhance immunity, take one lozenge daily.

Liquid

For treatment of influenza and colds, take four tablespoons daily at onset of symptoms. For long-term treatment to enhance immunity, take one tablespoon daily.

TOXICITY No side effects for Sambucol® have been reported in the medical literature.

NINE / KIDNEY AND URINARY TRACT INFECTIONS
Uriplex™

FORMULA CONTENTS
- Silver Birch (*Betula pendula*)
- Indian Kidney Tea (*Orthosiphon aristata*)
- Goldenrod (*Solidago virgaurea*)

MAJOR USES
- Urinary Tract and Kidney Infections
- Urinary Tract and Kidney Infections During Pregnancy

BACKGROUND

Within the kidneys are over one million filtering units (glomureli) designed to remove wastes and regulate water, electrolyte and acid/alkaline levels in the bloodstream. The kidneys' role in maintaining a healthy balance of critical elements in the blood is one most of us remain unaware of—until problems strike.

One of the key assurances of healthy kidney functioning is the optimum output of wastes and the proper synthesis of minerals. Urine, which is usually sterile, flushes out the system when a person is properly hydrated. This is especially important in cases of infection. But due to medical conditions, pharmacological side effects and poor health, output can be diminished, allowing harmful bacteria to propagate and for minerals to build-up in the kidneys.

When excess minerals and other substances build-up in the kidneys, they may end up forming stones which are damaging and painful to pass when they are too large. However, the most common urinary tract complaint is inflammation due to infection. When the kidneys or urinary tract become inflamed from bacteria the filtering units are compromised and over time can become scarred, a process known as sclerosis.

In Germany, physicians often recommend to their patients a highly unique herbal blend to combat both kidney disease and generalized urinary tract infections. The formula, known in America as Uriplex™, is comprised of silver birch, Indian kidney tea and goldenrod.

Due to the diuretic properties of the herbs in Uriplex™, the formula provides proven, effective support for normalizing urinary output and supporting healthy kidney function. The herbs, individually described below, are each long-standing agents in the treatment of kidney disorders. In combination, their bioactive compounds complement one another, producing an even more effective treatment option.

FORMULA BREAKDOWN

Silver Birch

Silver birch, or *Betula pendula*, is most widely recognized as an ornamental tree in landscaping, with its white bark and shimmering leaves. Yet, this beautiful tree has been appreciated for functional reasons throughout the ages.

Native Americans have used all parts of this tree as part of their medicine. The bark, used for baskets, was also made into a poultice for skin wounds. Birch leaves were used in the treatment of urinary tract infections. The active compounds in the leaves, flavonoids and saponins, have diuretic as well as antiseptic properties. In addition, the leaves contain methyl salicylate, which has analgesic properties.

Indian Kidney Tea

Also known as *Orthosiphon aristata* or java, Indian kidney tea is a member of the labiate family and a close relative of the mint family. Indian kidney tea grows wild in the Sunda Islands and Australia and is considered an important medicinal plant by the Malays.

Today, Indian kidney tea is cultivated as a crop and listed as a medicinal plant in the French, Indonesian, Dutch and Swiss pharmacopoeias where its use is often discussed in the context of treatment of kidney diseases. Its leaves contain lipophilic (fat-soluble) flavones, primarily sinensetin, which are thought to promote elimination of fluids, nitrogenous substances and sodium chloride from the body. The plant also contains potassium, which also accounts for its effectiveness in treating kidney-related complaints.

Goldenrod

Goldenrod is a vital healing plant Native Americans have long used as a tea for treatment of edema. In contemporary clinical studies, goldenrod has been found to directly increase renal function and to stimulate the elimination of fluids.

Urinary Tract and Kidney Infections

Uriplex™ may be used in the treatment of any generalized urinary tract or kidney infection and may be used with your doctor's recommended antibiotic regimen.

Urinary Tract and Kidney Infections During Pregnancy

Aucte pyelonephritis. No pregnant woman wants to hear the diagnosis or face the pain of a kidney infection; yet, suddenly developing one during pregnancy is by no means uncommon. Suffering from urinary tract infections, however, may be particularly distressing during pregnancy when doctors recommend discontinuation of antibiotics or other drugs due to their potential complications (such as gastrointestinal complaints and possible effects on the fetus). However, the herbal combination in Uriplex™ has been called "an absolutely suitable preparation for long-term treatment of renal diseases, also during pregnancy."

Uriplex™ can be purchased in film-coated tablets. Tablets should contain 109 mg dried extract of birch leaves, 97 mg dried extract of Indian kidney tea leaves and 136 mg dried extract of goldenrod.

Take one or two tablets three times daily.

No contraindications or side effects have been reported. The formula may be used during pregnancy. All ingredients have been approved and documented by the German Commission E.

TEN / PROSTATE DISEASE FORMULA

Cernilton®

FORMULA CONTENTS
- Pollen Extract

MAJOR USES
- Benign Prostatic Hyperplasia (BPH)
- Colds

BACKGROUND

The management of prostate disease by both patients and their doctors is fast becoming a major problem in the United States. More than 300,000 prostatectomies, the gold standard for the treatment of malignant forms of this disease, are performed in this country each year. What's more, an American male diagnosed with benign prostate disease can expect to spend $600 to $700 annually on synthetic drugs which must be taken for life and whose full long-term side effects remain largely unknown.

The most common prostate disease is called benign prostatic hyperplasia (BPH). When a man reaches forty years of age, his testosterone levels naturally begin to decline due to the increased activity of an enzyme called 5-alpha reductase which converts testosterone into a toxic metabolite called dihydrotestosterone (DHT). High levels of DHT in turn cause an overproduction (hyperplasia) of prostate gland cells. The end result is an enlargement of tissue.

The prostate gland is located beneath the bladder and when it becomes inflamed it can put pressure on the urethra, creating a myriad of urinary complications. Symptoms include incomplete emptying of the bladder, dribbling, frequent urination, particularly during the night, and sometimes the inability to urinate at all.

Conventional medical treatments for BPH include conservative measures like prostatic massage and diet modification. Prescription drugs such as hytrin or finasteride may be prescribed. In the last few years, medical doctors have introduced finasteride (Proscar) to their treatment regimen. Finasteride blocks formation of DHT, the "bad" hormone that promotes prostate cell growth. By blocking the action of the 5-alpha reductase enzyme, finasteride can shrink prostate tissue and restore urinary function in three to twelve months. The downside to finasteride and other synthetic drugs used to treat Prostate disease is that these drugs must be taken for life and have both known and yet-be-determined long-term side effects. According to Dr. A.C. Block of the Department of Urology at University Hospital of Wales in England, "Most of the pharmacological agents used to block hormonal or sympathetic neurological pathways that influence prostate growth and function are known to have side effects."

Finasteride was introduced with much fanfare in 1992 by Merck & Company and by 1994 was being used by some half-million men in 25 countries. But finasteride has not set the medical world on fire with its results. A 1992 report in *The New England Journal of Medicine* (*NEJM*) notes that improvement in symptoms of men suffering BPH, including urinary flow was "not impressive." Moreover, although rapid regression of the enlarged prostate gland occurs in most men, less than 50 percent experience an increase in urinary flow and improvement of BPH when treated with finasteride for 12 months.

Men with mild symptoms appear least likely to benefit. According to the *NEJM* report, finasteride might help in a "small number of men" with moderate-to-severe, but not life-threatening, symptoms, including weak urinary stream, socially embarrassing hesitancy, or frequent nighttime trips to the bathroom. Moreover, no published study has addressed the question whether finasteride prevents progression of the disease.

The short-term side effects associated with finasteride include decreased libido and impotency in some 10 percent of men. As for long-term side effects, finasteride has caused cancer and significant reproductive damage in rodents. (Finasteride tablets should not be handled by pregnant women or those who may become pregnant because of the potential for absorption and subsequent potential risk to the male fetus. Men should discontinue its use when their sexual partner is or may become pregnant.) Another concern is finasteride will cause a reduction

in serum PSA levels even in the presence of prostate cancer; thus, finasteride may "mask" the detection of prostate cancer. Finasteride should not be your drug of first choice.

Recently approved for use with BPH, hytrin is more commonly known as a blood pressure medication. Hytrin, and other similar acting high blood pressure medications now being prescribed for BPH, work by relaxing smooth muscle tissue including the muscles at the bladder opening, thus relieving obstruction and allowing better urine flow.

The United States Food and Drug Administration (FDA) has noted that urinary flow rate and symptom relief were improved more rapidly in hytrin patients than in those using Proscar. Similar drugs such as minipress have also been shown to improve BPH symptoms in the short-term. The real question, however, is their long-term effectiveness. The longest controlled studies of these drugs in the treatment of BPH were only six months in duration.

Hytrin and related medications, however, pose both short- and long-term side effects. One of the major short-term side effects associated with their use is a drop in blood pressure which can cause the patient to collapse when trying to stand or suffer dizziness; this is most likely to happen when the drug is first prescribed. If these drugs are used, they should initially be given in a one milligram (mg) dose at bedtime. Dosage should then be increased slowly. Moreover, patients should avoid driving or hazardous tasks for 12 hours after the first dose, after a dosage increase, and after interruption of therapy when treatment is resumed. Among other adverse reactions are weakness, headache, nasal congestion, palpitations, rapid pulse, nausea, swelling of the ankles, dizziness, abnormal neurological sensations, sleepiness, shortage of breath, nasal congestion, and blurred vision.

Long-term side effects for hytrin include cancer, as well as testicular atrophy and reproductive toxicity in laboratory animals. Its safety in pregnancy has not been established. On the other hand, minipress has shown no evidence of carcinogenicity or reproductive effects.

In severe cases of prostatic enlargement, surgery is considered. Some 25 to 30 percent of men with BPH ultimately require surgery. Compared with other treatments, surgery often has the best chance for relief of BPH symptoms and, ultimately, the lowest cost. Surgery, indeed, may be appropriate for some men. However, men should recognize that some surgical procedures offer only temporary benefits to a significant num-

ber of patients, and complications can result in major problems including incontinence and impotency. Four major types of surgery are most frequently performed.

The surgery of choice a few years ago, transurethral dilation, is an example of the urological community embracing procedures without adequate evidence of long-term benefits. Also known as balloon dilation, transurethral dilation uses the same principle as balloon angioplasty for treating clogged arteries. After being positioned within the prostate, via a catheter inserted into the urethra, a balloon is inflated, opening the passage for urine flow, spreading the prostate, and splitting surrounding tissue. This procedure has plummeted out of favor now that the long-term results show its benefits can be only temporary and that there is a "significant failure rate" with about 30 percent to 40 percent of patients requiring retreatment. In other words, for all the discomfort and attendant risks of surgery, all a lot of men received was a temporary solution! In spite of these drawbacks, the federal government, in its published 1994 BPH treatment recommendations, continues to recommend balloon dilation.

A newer procedure, transurethral resection of the prostate (TURP), can be more helpful than drugs, and ultimately less costly and safer. After the patient receives anesthesia, the surgeon inserts a special instrument into the urethra through the penis. No skin must be cut, and part of the inside of the prostate is removed. The procedure requires the patient to use a catheter for two to three days and a stay in the hospital of about three days. This procedure is relatively effective and has been demonstrated to have long-term benefits for most patients. The procedure also has complications, including incontinence and impotency, in nearly 20 percent of patients. Moreover, up to 15 percent of men who undergo this procedure require repeat surgery within eight years.

Transurethral incision of the prostate (TUIP) is a variation of the TURP procedure and sometimes used instead of TURP when the prostate is not as enlarged. In this procedure, tissue is not removed. Rather, an instrument is passed through the urethra to make one or two small cuts in the prostate. These cuts reduce the prostate's pressure on the urethra, making it easier to urinate. Although TUIP is often slightly less effective than TURP, most patients will show symptom improvement. There is minimal chance of becoming impotent after surgery. About one in ten may require retreatment within the first five years following this procedure.

Open prostatectomy is the most radical of surgical procedures and is only used if the prostate is very large. In this procedure, an incision is made in the lower abdomen to remove part of the inside of the prostate. Most patients show improvement with this surgery. But there is a cost: men who undergo this surgery have about a one-in-five chance for complications. Depending on the specific type of procedure used, the risk of impotency following surgery can be as high as about one in three. The surgery is also the most traumatic, requiring a longer hospital stay and recuperation. Before submitting to this radical surgery, men should do themselves a favor and get a second opinion, as well as consider other options. Many urologists are now performing the TURP procedure instead of open prostatectomy.

However, I believe men should also consider use of Cernilton®, which may alleviate the need for drugs or surgery altogether.

MAJOR USES
DEFINED

Benign Prostatic Hyperplasia

Cernilton® was introduced to the European market over 30 years ago and continues to be used as a first-line defense for patients with mild to moderate BPH. Studies indicate it is effective in reducing inflammation of the prostate and relieving congestion within the organ.

In 1990, British physicians tested Cernilton's® effectiveness in treating BPH-related impaired urine flow. Sixty patients were involved in the study, half receiving Cernilton® and the other half placebo. After six months, 69

Beware, Mainstream Medicine's Help

The fact is that, by age 60, at least half of all American men become afflicted with obvious symptoms of an enlarged prostate (also known as benign prostatic hypertrophy/hyperplasia, or BPH). For some men, this may result in only minor discomfort and be stoically shrugged off as simply a condition of aging. Other men, for whom the symptoms are more severe, will seek medical help. Yet, the "help" offered by the urological community can be as devastating as the disease—sometimes worse. The fact is the mainstream American urological community simply has not served the best interests of BPH-afflicted men.

Fortunately, there are plant drugs that successfully address functional complaints of the urological system. One such drug is Cernilton®, a flower pollen extract manufactured in Sweden. Cernilton is made from cernitin, the pollen from several different plants grown in Southern Sweden.

percent of the patients reported improvement in symptoms. Researchers also found a decrease in residual urine and prostate diameter.

In another study, 79 patients with BPH were treated with Cernilton® three times a day for more than 12 weeks. Their symptoms ranged from urinary flow obstruction, increased prostatic volume, and residual urine. Scientists reported that the extract produced a statistically significant improvement of 69 percent compared with an improvement of 30 percent with placebo. A decrease in residual urine volume and in the prostate size was observed.

Finally, in 1990, 192 patients were treated with Cernilton®. After four weeks moderate or great improvement was seen. Patients reported improvement in residual urinary volume, average urine flow rate, maximum flow rate, and decreased prostate weight.

Colds

Researchers have just begun to test Cernilton's® effectiveness in treating the common cold. In Poland, scientists ran a double-blind, placebo-controlled trial in 775 patients with common cold symptoms. Test results showed that under certain conditions such as sore throat and coughing, the prophylactic effects of Cernilton® were very beneficial.

WHAT TO LOOK FOR

Cernilton® is manufactured by AB Cernelle, located in Sweden. It is a microbial digestion of a mixture of pollens which have been first extracted in water, followed with extraction in an organic solvent. Cernilton® is now available at health food stores and natural product supermarkets throughout the United States.

RECOMMENDED DAILY DOSAGE

Take two to four tablets daily.

TOXICITY

There are no reports of complications for this product mentioned in the medical literature.

ELEVEN / ARTHRITIS FORMULA

Phytodolor™

FORMULA CONTENTS
- Aspen (*Populus tremula*)
- Common Ash (*Fraxinus excelsior*)
- Goldenrod (*Solidago virgaurea*)

MAJOR USES
- Arthritis (all forms)
- Post-surgical Pain Relief

BACKGROUND

There are more than 100 types of joint disorders—each debilitating and painful. For many people, joint pain manifests itself merely as achiness and stiffness. For others, the pain is severe and often times leads to crippling deformity. Osteoarthritis, also known as degenerative joint disease, is the most common form of joint disorder. In this disease, years of wear and tear on joints eventually leads to cartilage breakdown.

Rheumatoid arthritis is less common, though potentially much more debilitating than osteoarthritis. This disorder affects not only the joints but also the surrounding tissue. Rheumatoid arthritis usually occurs in middle age and tends to strike the feet, hands, and arms. The devastating effect of this illness is twofold. First, rheumatoid arthritis is a chronic disease. Second, it requires lifetime treatment. A single-dose therapy cannot ease the condition. Therapy must be given for an extended period of time, then must be changed periodically to stimulate the body into a fresh response.

In the past century, medicine has made great progress in the treatment of arthritis. Advances in surgical procedures and drug therapy continue to reach the market; however, conventional therapy is not without problems. Pharmaceutical treatment includes the use of corticosteroids

and/or non-steroidal anti-inflammatory drugs (NSAIDs). However, many studies have shown that these treatments produce numerous side effects, namely skin irritation, headache, dizziness, and gastrointestinal irritation, including bleeding and ulcers. In fact, a high incidence of ulceration is tied to NSAID use. Patients who try NSAID therapy tend to discontinue therapy after a short period of time. What's more, when treatment is stopped, the healing effect stops. In 1991, eighteen-billion dollars was spent on NSAID treatment in the United States and nearly another six billion to treat related side effects.

Nature provides us with a gentle and effective treatment option. In Germany, research scientists have developed Phytodolor™, a proprietary all-around arthritis formula.

Available on the German market since the early 1970s, this formula now heads the ranking list for arthritis treatment. Nearly 100 pharmacological studies indicate that Phytodolor™ is an excellent anti-inflammatory agent with very good tolerance. Fortunately for those suffering from arthritis, this formula is now available in the United States (see Resources).

FORMULA BREAKDOWN

Aspen Tree

This tree, belonging to a group of willow plants, grows abundantly in Germany. Since ancient times, the bark has been used for wound healing and arthritis treatment. Now, manufacturers use both the leaves and the bark of the tree in a ratio of 1:1 for an extract containing this plant's bioactive compounds. These important compounds, salicin and populin, play an important role in Phytodolor™.

Common Ash

Common ash belongs to the olive tree family. Since ancient times this tree has been used as an herbal healer. It can grow to a height of more than 120 feet. Its bark contains healing properties for arthritis.

Goldenrod

Along hillsides and deep in the pine woods grows a tiny yellow flowering plant called goldenrod. This long-heralded medicinal plant has been used as a diuretic dating back to the early 17th century. German scientists have found the flowers of this plant can also help ease arthritis symptoms.

Arthritis (all forms)

A total of 1,151 patients have participated in thirty clinical studies to determine the efficacy and tolerance of this herbal formula.

In one controlled, randomized eight-week study, 50 patients undergoing treatment with an orthopedic specialist were given thirty to forty drops of Phytodolor™ three times daily. The formula reduced their pain and therapeutic success was judged good to very good in eighty percent of the cases. Only 20 percent reported a moderate improvement.

Thirty patients with arthritis of the knee were tested in a single-blind, randomized clinical study. They were given either Phytodolor™ or a prescription drug commonly used for this condition. The results indicated Phytodolor™ worked as effectively as the prescription drug for reducing pain and joint swelling. In addition, Phytodolor™ increased the passive and active mobility of the joint.

In 1988, 40 residents of a retirement home, suffering from painful degenerative arthritis of the vertebral column, took part in a trial. Following a six-week period in which the study participants were given 40 drops of the formula three times a day, two-thirds judged the efficacy of Phytodolor™ as good to very good. Researchers concluded that Phytodolor™ can satisfy the most common needs of the elderly for an anti- inflammatory medication, yet without side-effects. This complex of herbs is also suitable in fulfilling the treatment requirements of patients over a long period of time.

Post-surgical Pain Relief

I don't know about you, but whenever I've had to undergo surgery, there's always been post-surgical pain. In the first few days following surgery, a strong synthetic painkiller such as hydrocodone may be given, which brings relief. Problem is, with repeated use (even over only a few days), such drugs make me feel out of sorts.

Phytodolor™ has shown strong evidence of replacing post-surgical drugs or minimizing their required dosage.

In a recent study, groups of 15 post-surgical patients who had undergone knee surgery were given either 3 x 30 drops of the plant-based agent Phytodolor™ and, where necessary, the painkiller diclofenac additionally, or diclofenac only.

Without Phytodolor™, the patients used an average of 4.7 25 mg diclofenac pills per day. With Phytodolor, the average daily diclofenac consumption fell to less than one (0.3 x 25 mg).

Thus, while Phytodolor™ reduced dependency on the synthetic painkiller by nearly sixteenfold, pain and swelling remained "virtually the same," indicating that the pain relieving qualities were equivalent. There were three cases of gastrointestinal complications in the diclofenac group, none in those persons taking Phytodolor™.

Phytodolor™ is prepared in a liquid format and contains standardized extracts of common ash, aspen and goldenrod.

WHAT TO LOOK FOR

Take twenty to thirty drops three to four times daily. In case of chronic pain, forty drops may be taken three to four times daily. Allow four to eight weeks for best results.

RECOMMENDED DAILY DOSAGE

No serious side effects have been reported. In rare cases, transient nausea may occur. Persons who are alcohol-sensitive should avoid use of this product.

TOXICITY

TWELVE / UPPER RESPIRATORY SUPPORT FORMULA
SinuGuard™

FORMULA CONTENTS
- Gentian Root (*Gentiana lutea*)
- Cowslip Flower (*Primula veris*)
- Sour Dock (*Rumex acetosa*)
- Elderflower (*Sambucus nigra*)
- Verbena (*Verbena officinalis*)

MAJOR USES
- Sinusitis
- Bronchitis

BACKGROUND

According to the *Journal of the American Medical Association*, a survey of over 1,500 U.S. physicians showed that 21 percent of the 12 million prescriptions written for sinusitis and bronchitis in 1992 were inappropriately prescribed. Children and adults suffering from sneezing and wheezing often go to their physician in search of a magic bullet—an instant cure. What they aren't told is that 90 percent of all colds, bronchitis and upper respiratory tract infections are caused by viruses or represent allergies and that they will not respond to antibiotics. Frequent and inappropriate use of common antibiotics is a serious and growing concern. What's more, it is increasingly evident that when antibiotic therapy is given in appropriate conditions, it is still necessary to provide treatment that can increase physical strength and resistance.

Antibiotics may help to kill germs or inhibit their growth. But your body must rally its immune system resources to do the rest. When a nasty cold or flu sets in or if you're suffering from seasonal allergies, I suggest you first turn to nature's pharmacy for relief.

Since 1934, Germans have successfully relied on an herbal formula known in the United States as SinuGuard™ to treat upper respiratory tract infections. In fact, this formula is now the most prescribed natural plant-based medicine in Germany. Its mechanism of action and efficacy are extraordinarily well documented.

Repeated studies show SinuGuard™ has distinct anti-inflammatory and decongestive properties. Fortunately, this outstanding product is now available in the United States (see Resources).

Gentian Root

In high mountain regions from the Alps to Asia Minor, a robust yellow flower called *Gentiana lutea* grows. For centuries the plant has been harvested for medicinal purposes, primarily to support the digestive system. Gentian is a "pure" bitter which contains important glycosides. When the root is dried and prepared into a tincture it can be used to stimulate gastric secretions. However, more recent research indicates the plant has further properties for use in treatment of colds and bronchitis.

Cowslip Flower

Cowslip, a flowering yellow plant, grows in the damp meadows of Eastern Europe, including East Germany. The roots of cowslip contain saponins, glycosides and volatile oils. Saponins are key to the plant's healing action. Just how saponins work is not yet understood, but research indicates they lead to increased bronchial secretion and productive coughs. Cowslip is used in a host of proprietary European products.

Sour Dock

Sour dock belongs to the buckwheat family. It grows in meadows throughout the world. It was once classified under the genus *Lapathum*, meaning to cleanse. Its edible greens contain oxalic acid and have long been used as an astringent for diseases of the blood. The root of the plant acts as a laxative and a remedy for anemia due to its ability to draw iron from the soil.

Elderflower

Elderflower is a common shrub with white flowers and black berries. Elderberry juice and wine have long been used as herbal tonics, specifically to support the immune system. This formula uses the flowers of the elderberry plant for their ability to increase the overall health of the immune system.

Verbena

The roadsides of Northern Europe are dotted with the decorative herb, verbena. This perennial plant with pink or lilac flowers is a native

FORMULA BREAKDOWN

of Europe and is now naturalized in North America. Historically, it was used medicinally to help vision problems, but more recently it has gained attention from medical professionals for its use in respiratory disorders.

MAJOR USES
DEFINED

Sinusitis

Sinusitis occurs with various degrees of severity, each requiring a different therapy. In cases of acute bacterial sinusitis the most common medication includes antibiotics and decongestants. In Germany, however, scientific studies show that adding the herbal formula in SinuGuard™ supports and enhances these therapies.

In one study, one-hundred-sixty men were involved in a two-week trial. Eighty-one men were given the formula along with their conventional therapy and seventy-nine were given a placebo and conventional therapy. Researchers assessed the effectiveness of the formula by monitoring severity of symptoms including nasal secretions, headaches and nasal blockage. Results showed that those receiving the formula had significantly fewer and less severe symptoms than those receiving only conventional therapy and placebo.

Bronchitis

Studies indicate that the herbal formula in SinuGuard™ is a well-established therapy for the upper respiratory tract. Experiments show that this formula possesses distinct anti-inflammatory and decongestive properties.

WHAT TO
LOOK FOR

SinuGuard™ is available in tablet form. When purchasing a tablet, look for one that contains 12 mg of gentian root, 36 mg of cowslip, 36 mg of sour dock, 36 mg of elderflower, and 36 mg of verbena.

RECOMMENDED
DAILY DOSAGE

Adults may take two tablets, and school age children one tablet, up to three times daily.

TOXICITY

SinuGuard™ is well tolerated and without interactions or contraindications, including during pregnancy.

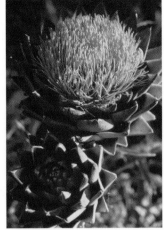

Artichoke
Cynara scolymus

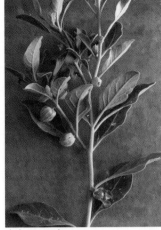

Ashwaganda
Withania somnifera

Aspen
Populus tremuloides

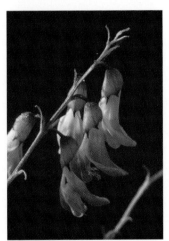

Astragalus
Astragalus membranaceus

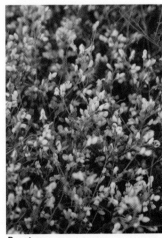

Baptista
Baptisia tinctoria

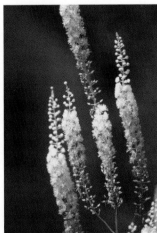

Black Cohosh
Cimicifuga racemosa

Bee Pollen
Apis mellifica

Photographs: ©2000 Steven Foster

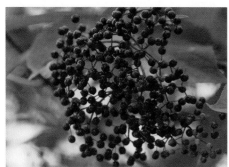

Black Elderberry
Sambucus nigra

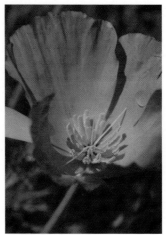

California Poppy
Eschscholzia californica

Cat's Claw
Uncaria tomentosa

Coleus forskohlii Root
Coleus forskohlii

Gold Thread
Coptis groenlandica

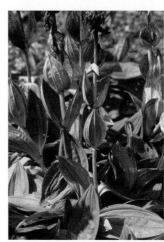

Gentian
Gentiana lutea

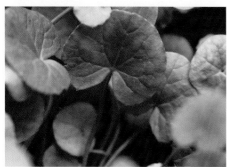

Gotu Kola
Centella asiatica

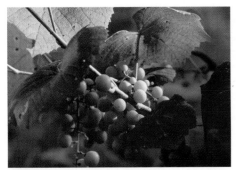

Grape
Vitis vinifera

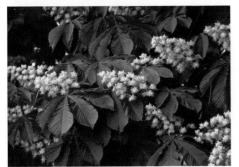

Horse Chestnut
Aesculus hippocastanum

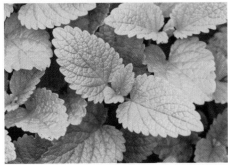

Lemon Balm
Melissa officinalis

Gymnema
Gymnema sylvestre

Khella
Ammi visnaga

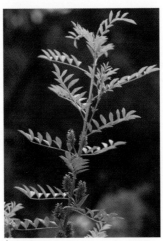

Licorice
Glycyrrhiza glabra

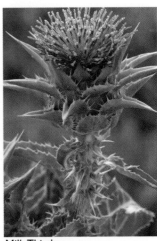

Milk Thistle
Silybum marianum

Muira Puama
Ptychopetalum olacoides

Peppermint
Mentha x piperita

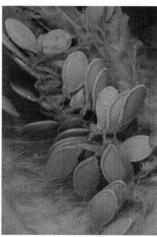

Pumpkin
Cucurbita pepo

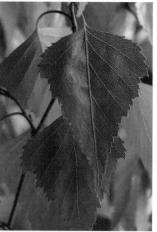

Schisandra wu-wei-zi
Schisandra chinensis

Silver Birch
Betula pendula

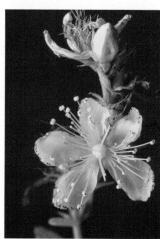

St. John's Wort
Hypericum perforatum

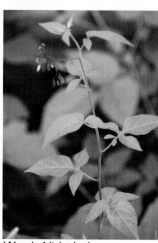

Woody Nightshade
Solanum dulcamara

Individual Herbs for Health

The old paradigms of modern medicine are crumbling.
There is no question that medical drugs are critically important to
health and well-being, especially in acute situations. However, for
the lengthening "marathon" of life today, we need a different kind of
medicine. A more natural medicine that is in tune with the body.

—Terry Lemerond
President, Enzymatic Therapy

ONE /
Artichoke Leaf

COMMON NAME: Artichoke Leaf

BOTANICAL NAME: *Cynara scolymus*

MAJOR USES

- Dyspepsia (Indigestion)
- High Cholesterol
- Bile Disorders
- Liver Disease
- Gallstone Disorders

BACKGROUND

Artichoke is a thistle-like plant with violet blossoms that grows up to six feet tall. The lowly artichoke is one of the best researched medicinal plants, but due to the health media's attention on so many other herbs, health-conscious consumers have developed little, if any, recognition of artichoke extract and its valuable medicinal properties. Besides being a fantastic digestive aid, however, artichoke extract helps lower cholesterol and triglycerides, stimulate bile flow, and protect liver tissues.

As early as the Middle Ages, an association between the artichoke as a medicinal plant and the liver was known. Indeed, ancient doctors knew what modern science has confirmed. Enhancement and balance of the body's bile secretions is essential for the treatment of cholesterol as well as indigestion.

Artichoke extract is also a potent antioxidant. That means it protects cells from damaging free radicals and may prove helpful in all free radical-related disorders such as cataracts, hardening of the arteries, and liver disease. Artichoke extract's antioxidant properties make it a candidate for anyone's longevity program and well worth integrating into one's daily nutritional regimen.

MAJOR USES
DEFINED

Dyspepsia (indigestion)

Fed up with chronic gas, nausea, belching, bloating and even vomiting? Ask your doctor for help and he or she will probably respond by first taking your history and performing a physical examination. Your doctor will examine the esophagus and check for any types of perforations as well as test you for the presence of ulcer-causing *Helicobacter pylori*. If the finding for *H. pylori* is positive, the patient will be treated with drugs such as omeprazole (Prilosec), Pepto-Bismol, and various antibiotics. If the findings for *H. pylori* are negative, the doctor usually writes out a prescription for a drug that will relieve symptoms temporarily by interfering with the natural digestion process and blocking the body's acid secretions, or by telling the patient to simply take more Tums or another OTC antacid.

If the doctor is still not sure what's causing a patient's indigestion, the patient may be given an upper gastrointestinal tract x-ray or the doctor may use an endoscope to rule out stomach cancer.

Very often, however, these quick fixes offer no permanent solution. The problem is that the next time you eat you will once again end up suffering from uncomfortable, sometimes embarrassing symptoms of indigestion.

Using typical prescription or over the counter drugs offers a temporary fix but doesn't attack your problem at the source. Your doctor has treated

What is indigestion?

If you feel gaseous or bloated, suffer excessive flatulence, constipation, nausea or even must vomit after meals on a regular basis, then you may be suffering from chronic indigestion. Known medically as dyspepsia, indigestion is characterized by upper abdominal discomfort and pain with bloating and fullness after eating. Other symptoms can include belching, bloating, burping, heartburn, loss of appetite, regurgitation, early feeling of fullness, perhaps even nausea and vomiting. The symptoms typically occur one to two hours after a meal and may be temporarily improved by taking antacids. About one-third of Americans today suffer from chronic indigestion.

Mild, occasional indigestion is generally transient and self-limiting without the need of medical care. But when indigestion becomes a chronic problem that accompanies practically every meal, then you have a serious problem. Often overlooked by the medical profession is that a significant cause of indigestion is not necessarily oversecretion of hydrochloric acid but the result of poor liver function—particularly what medical experts call congested liver by which it is meant that bile flow is inhibited.

This liver disorder, which is also called cholestasis (lack of bile flow), impairs the body's ability to properly digest and utilize the foods taken in during a typical meal. This may lead to constipation and other symptoms of indigestion.

your symptoms but without initiating the healing process. The real solution to indigestion is to understand the cause and attack the problem at its root.

What's more, some such drugs for indigestion may be cancer-causing or disturb hormonal balances in men and women (see page 87).

When more serious illnesses are ruled out, doctors practicing complementary medicine prefer to treat their patients with natural therapies such as dietary changes and nutritional supplements. Still, indigestion is a difficult condition to heal and doctors are always looking for new natural approaches to addressing this problem. That is why I predict artichoke extract will soon be recognized as a welcome addition to the practice of complementary medicine.

Artichoke extract is still new to most doctors in the United States. Artichoke extract has been used in France since the 1970s. Along with the Hippocratic Oath, "Do no harm," artichoke extract is safe and worth a try to help people who are suffering chronic indigestion. It's a different way of looking at helping persons with indigestion but definitely a viable way of addressing the problem. Artichoke extract is a natural cure that will attack your indigestion problem at its source.

How Artichoke Extract Works

Artichoke extract is one of the few known safe substances today that actually stimulates the liver's bile flow. An often overlooked key to optimal digestion is healthy bile flow. Bile is a viscid, alkaline, yellowish-green fluid excreted from the liver, stored in the gallbladder, and released into the intestine to aid in the digestion and absorption of fats. Bile contains more than 97 percent water. Its most important components are bile salts including bile acids, cholesterol, lecithin, cations (Na, K, and Ca) and anions such as chloride and bicarbonate.

Bile acids are natural detergents. They induce bile flow and liquefy fats that the body takes in. Bile also plays an important role in softening the stool by promoting the incorporation of water. Without enough bile, the stool can become quite hard and difficult to pass. Bile also helps to keep the small intestine free from pathogenic microorganisms.

Disturbances of the liver's bile flow often lead to intolerance of fat and dyspepsia. Today, it is increasingly being recognized that an increase in bile secretion is regarded as an essential and effective principle in the treatment of indigestion. Both experimental and clinical human studies have shown that indigestion is rooted in gastric and bile flow disorders.

Causes of Cholestasis

- Presence of gallstones

- Alcohol

- Endotoxins

- Hereditary disorders such as Gilbert's syndrome

- Hyperthyroidism or thyroxine supplementation

- Viral hepatitis

- Pregnancy

- Certain chemicals or drugs:

 Natural and synthetic steroidal hormones

 Anabolic steroids

 Estrogens

 Oral contraceptives

 Aminosalicylic acid

 Chlorothiazide

 Erythromycin estolate

 Mepazine

 Phenylbutazone Sulphadiazine

 Thiouracil

Increased choleresis or optimal flow of bile can lead to improved intestinal motility and a higher activity of fat digestion.

In today's view, the activity principle of choleretically active natural medicines such as artichoke extract is therefore seen as beneficial both in secretory support of the digestive activity and in the influence on intestinal motility. However, only a very few preparations have a proven choleretic effect.

Most typically, doctors recommend drugs known as H2 receptor antagonists like cimetidine (Tagamet®), famotidine (Pepcid®), and ranitidine (Zantac®). These drugs which are available over the counter work by occupying sites on the surface of gastric cells. These sites are called histamine H2 receptors. When specific types of histamines (a type of substance composed from ammonia) attach to them, these receptors signal the stomach cells to secrete various chemicals such as hydrochloric acid that help to digest food. By taking up residence on these receptors the drug prevents histamines from occupying the spaces on these receptors and turning on these cells. The volume of acidic secretions in the stomach is reduced. This temporarily reduces your symptoms. But this is only a temporary solution, since excess acid secretions are not always the cause of indigestion but merely a symptom.

Drugs such as antacids (Mylanta, Maalox, or Tums) can help to neutralize stomach acidity by adding a buffering mineral such as calcium.

Motility enhancement drugs are also used. These include cisapride (Propulsid®) or metoclopramide (Reglan®). These work by stimulating gastric emptying of both solids and liquids.

Although most often, these side effects or complications are mild, they may be quite serious in some patients. For example, people using famotidine or ranitidine may be more likely to suffer from mild to severe headaches, dizziness, constipation and diarrhea.

Work with Your Doctor to Rule-out Other More Serious Causes of Indigestion

Occasionally, indigestion can be a symptom of another, more serious problem. For this reason, to insure that your chronic indigestion is not indicative of a more serious problem, you should see your doctor for a thorough check-up. Chronic indigestion may also be associated with conditions such as Crohn's disease; colon cancer; inadequate or excess stomach acid; inflammatory conditions of the stomach or pancreas; ulcers; scleroderma; lupus; parasites or amoebae; even a weak heart; or diabetes.

The complications from cimetidine may be more serious. While not cancer-causing in rodents, cimetidine does alter the body's metabolism of estrogen, causing gynecomastia in men. These estrogenic effects are consistent with a single report of breast cancer in a man who had been treated with cimetadine. "After being on [the drug] for eight months ... he was found to have a hard malignant mass replacing his right breast." Clearly, toxicology studies on this drug are overdue, especially as it is in very common use.

Safe Shopper's Chart: Artichoke Extract vs. Medical Drugs for Indigestion

Typically Prescribed Drug	Adverse Reactions/Possible Chronic Toxicity
Artichoke Extract	None.
Magnesium hydroxide (Maalox, Milk of Magnesia, Mylanta, Tums)	No significant adverse or chronic effects. Possible drug interactions.
Cimetidine (Tagamet®)	Headaches, headaches, gynecomastia, impotence, decreased white blood cell counts, congested liver, increases in plasma creatinine, experimental evidence of possible carcinogenic effect.
Cisapride (Propulsid®)	Headache, diarrhea, abdominal pain, dyspepsia, urinary tract infection, increased frequency of urination, abnormal vision
Famotidine (Pepcid)	Headache, dizziness, constipation, diarrhea. Possibly arrhythmia, palpitations, tinnitus.
Metoclopramide (Reglan®)	Restlessness, drowsiness, fatigue and lassitude, depression, dystonia tardive dyskinesia, elevated prolactin (possibly increased cancer risk), gynecomastia, impotence.
Omeprazole (Prilosec®)	Abdominal pain, diarrhea, headache, possible carcinogenicity based on experimental studies.
Ranitidine (Zantac®)	Severe headache, dizziness, insomnia, vertigo, arrhythmia, constipation, diarrhea, nausea, increases in liver SGPT values, blood count changes

The Physicians' Desk Reference warns that serious heart arrhythmias have been reported in patients who are using cisapride with other medications, including some common antibiotics. The drug could potentially impair fertility, according to experimental studies.

Metoclopramide can cause mental depression including suicidal tendencies, Parkinsonian-like symptoms, and tardive dyskinesia; other complications include restlessness, drowsiness, fatigue and lassitude; levels of a hormone called prolactin may be increased which may increase women's risk for breast cancer.

As for omeprazole (Prilosec), it may be carcinogenic, based on experimental data reported on in *The Physicians' Desk Reference*. In two 24-month carcinogenicity studies in rats, omeprazole at daily doses approximately four to three-hundred-fifty-two times the human dose produced gastric ECL cell carcinoids in a dose-related manner in both male and female rats; the incidence of this effect was markedly higher in female rats, which had higher blood levels of omeprazole. Gastric carcinoids seldom occur in the untreated rat. In addition, ECL cell hyperplasia was present in all treated groups of both sexes. An unusual primary malignant tumor in the stomach was seen in one rat. No similar tumor was seen in male or female rats treated for two years. For this strain of rat no similar tumor has been noted historically, but a finding involving only one tumor is difficult to interpret. A 78-week mouse carcinogenicity study of omeprazole did not show increased tumor occurrence, but the study was not conclusive.

For a complete break-out of the safety of these commonly prescribed drugs, see page 87.

Abnormalities such as prolonged gastric (stomach) emptying time or flatulence are symptoms, not the cause, of chronic indigestion. Your body may be calling out for a natural choloretic medicine.

A choloretic is a substance that increases the formation and flow of bile. Artichoke extract relieves symptoms by enhancing bile flow and turning on the body's own innate healing powers. Scientific studies back up its benefits.

Medical Validation of Artichoke Extract's Benefits for Digestion

- As early as 1974, it was shown that artichoke preparations could increase choleresis (bile flow) in humans.
- These results were confirmed in a second study conducted in 1992 involving 403 patients with functional disturbances of the

bile duct. Some 78 percent of patients and 87 percent of the doctors who evaluated their treatment with artichoke extract rated the medicine as having "very good" effects.

■ In a 1993 study, it was shown that persons receiving artichoke extract showed a significantly higher increase in their average bile secretion when compared to persons receiving a placebo (dummy pill). In this study, twenty volunteers were given either artichoke extract or a placebo and increases in their bile volume were measured after 30 and 60 minutes. The bile secretions of persons receiving the artichoke leaf extract increased an average of 127.3 percent after only 30 minutes and 151.3 percent after one hour. In contrast, the highest measured volume of bile secretion among persons receiving only placebo was a mere 39.5 percent. The higher volumes were also present up to $2\frac{1}{2}$ hours later when compared to the group receiving the placebo. The researchers learned that the effects of artichoke extract occur within 30 minutes and continue for the next two hours. The researchers concluded, "It currently seems that the traditional physiotherapy of gastrointestinal disorders [with artichoke leaf extract] will once again find its deserved therapeutic rank."

■ In a 1996 study, artichoke leaf extract was studied in a six-week surveillance study in 553 patients with non-specific digestive disorders, particularly dyspeptic discomforts and functional bile duct discomfort with which they had been suffering an average of three years prior to the study. Their average age was 54.7 years. Average length of use was 43.5 days. Striking results were found among persons suffering from the most extreme symptoms. Showing improvement were: some 88 percent of patients suffering from vomiting syndrome; 82 percent with nausea; 76 percent with abdominal pain; 72 percent with loss of appetite; 71 percent with constipation; 68 percent with flatulence; and 59 percent with fat intolerance. The physicians judged the benefits to be derived from artichoke leaf extract as good to excellent in 85 percent of patients. The researchers concluded, "The results of the . . . study . . . confirm the therapeutic efficacy and high application safety [of artichoke leaf extract] with non-specific digestive disorders."

What Else Can be Done to Minimize
Symptoms of Chronic Indigestion?

- Avoid foods and medication that can aggravate your symptoms. This would include hot or spicy foods, anti-inflammatory drugs such as aspirin, ibuprofen or naproxen, and steroid medications.
- If you smoke, chew tobacco, or use nicotine chewing gum, quit. Smoking is an important cause of dyspepsia and slows the healing of ulcers. Your healthcare provider can give you information about quitting.
- Drink less alcohol, coffee (both caffeinated and "decaf"), black tea, and caffeinated soft drinks. They can irritate the stomach.
- Take it easy. If emotional stress contributes to your symptoms, try to identify and control sources of stress in your life.

High Cholesterol

We now know that lowering cholesterol levels by one percent in middle-aged people can decrease risk of a heart attack by two percent. Fortunately, artichoke leaf extract's beneficial effects on blood fat metabolism are so powerful that it is now becoming recognized as a potent, yet extremely safe cholesterol lowering herb by both natural health practitioners and medical doctors alike. Artichoke's benefits are on par with some of medicine's most powerful cholesterol-lowering drugs—but without their long-term complications. In a 1995 study, European doctors investigated *in vitro* (i.e., in the test tube) whether the extract of artichoke has a direct effect on liver cholesterol biosynthesis. Within two hours they found the extract initiated a highly significant concentration-dependent inhibition of cholesterol biosynthesis in cultured human cells. At least six clinical studies attest to its potent balancing effects on the body's cholesterol.

Bile Disorders

High doses of artichoke leaf extract are effective in treating metabolic disorders caused primarily by the body's poor bile flow. This is due to its stimulating effect on bile secretion. This choleresis-inducing effect of artichoke leaf extract has been verified in clinical double-blind studies. Its effect on bile also plays a role in lowering cholesterol due to bile's capacity to provide a major pathway for the elimination of cholesterol.

Liver Disease

Artichoke extract improves liver regeneration and protection. The most important findings are regeneration of tissues, increases in RNA content, and healthy cell division.

Gallstone Disorders

Experience has shown that artichoke has a beneficial and lasting effect in gallstone disease. Scientists have successfully used artichoke to control serum cholesterol levels. When serum cholesterol levels are reduced, gallstone formation often ceases completely.

For a medicinal effect, you must purchase the concentrated extract. Evidence shows that neither the fresh plant material nor isolated cynarin (as in a more drug-oriented preparation) achieve the potency of the extract. Seek brands that have been manufactured in accordance to meet or exceed the recommendations and safety standards set forth by the German Commission E. This means that the product should be standardized to contain 13 to 18 percent caffeylquinic acids and be prepared from the very large, one-year old base petals of plant. These are validated to yield the highest content of curative substance.

WHAT TO LOOK FOR

Take one to two 160 mg capsules of artichoke extract with, or after, each meal.

RECOMMENDED DAILY DOSAGE

Artichoke leaf extract has no known side effects or drug interactions.

TOXICITY

TWO /
Ashwaganda

COMMON NAME: Winter Cherry

BOTANICAL NAME: *Withania somnifera*

MAJOR USES

- Osteoarthritis
- Immunodeficiency
- Strengthening the Nervous System
- Anti-aging
- Cancer Prevention

BACKGROUND Ashwaganda is a small branching shrub that grows in arid, less populated subtropical regions of India, Pakistan, Afghanistan, Spain, the Middle East and Africa. Its roots are harvested for medicinal use and prized for their rejuvenating properties, which hold a special place in the ancient Indian science of Ayurvedic medicine. Pharmacological research is now identifying numerous medically useful compounds in the withania family that are thought to be responsible for its highly esteemed vitalizing property.

Of the 23 known species of withania, ashwaganda is the most highly researched. For medicinal purposes the roots and leaves are dried and prepared into capsules or tablets.

In India, this herb is often referred to as "Indian ginseng" because of its anti-stress protective functions. However, unlike some of the more fiery forms of ginseng (e.g., Red Koren Ginseng), ashwaganda lacks potent stimulant effects. Instead, ashwaganda acts to help tonify the muscular, nervous, reproductive, and hormonal systems. It is especially useful in cases of weakness due to overwork and nervousness, and also used in treatments for those suffering from the debilitating effects of chronic disease such as cancer.

Medical researchers recently termed the active compounds in ashwaganda as adaptogens—that is, agents which cause adaptive reactions

92

within the body that enable it to resist stress, particularly physical stress. Pharmacological research has shown it has a protective activity that takes on many functions in the body, including modulating blood pressure, muscle tone, cell reproduction, cartilage and joint integrity, fever, pain, inflammation, insulin sensitivity, and blood sugar. The herb's most active constituents include two glycowithanolids known as sitoindoside IX and sitoindoside X. Both have been evaluated for their modulating effects on the immune and central nervous system.

Osteoarthritis

MAJOR USES DEFINED

Osteoarthritis is the most common form of arthritis. Current drug therapies which offer non-steroidal anti-inflammatory drug treatment have limitations for long term use. But, ashwaganda's anti-inflammatory and analgesic properties are proven to be highly effective and very safe.

In a clinical trial of 42 patients over a period of three months, the medicinal effects of an ashwaganda root herbal/mineral compound were found to have significant impact on pain and disability of patients. While eight had mild side-effects such as discomfort, none self selected to discontinue therapy.

Immunodeficiency

Researchers have examined ashwaganda root's immunostimulating activities. Ashwaganda has been shown to have significant beneficial effects on the immune cell-producing bone marrow. The herb counteracts the undesirable affects of medications that suppress the body's ability to produce white blood cells, making it useful for persons undergoing chemotherapy or radiation for cancer treatment.

Strengthening the Nervous System

Choline, found in ashwaganda, strengthens the nervous system via stimulation of nerve tissue. Choline is also used by the brain to manufacture acetylcholine, a powerful neurotransmitter that affects learning and memory.

Anti-aging

Ashwaganda has a special place in Ayurvedic medicine as a longevity herb. Tonics prepared from the root were used by elders to maintain men-

tal and sexual vitality. The effect of ashwaganda on aging was studied in 101 healthy male patients ages 50 to 59. The men were given three grams of ashwaganda or placebo daily for one year. Test results showed a significant increase in hemoglobin and red blood cell counts, slowed graying of hair, less spinal height decrease, better calcium content in nails, and an improvement in sexual performance.

Cancer Prevention

Many studies have investigated ashwaganda's anticancer properties. The plant appears to increase the sensitivity of tumor cells to radiotherapy. In one such study, the herb increased the effect of radiation and heat treatments on tumor regression and growth delay.

WHAT TO LOOK FOR

Ashwaganda should be standardized to contain 1.5 percent withanosides, the herb's active constituents. Be sure to buy a formula from a reputable manufacturer to eliminate any chances of heavy metal or bacterial contamination.

RECOMMENDED DAILY DOSAGE

Take the equivalent of one standardized 450 mg capsule one to three times daily.

TOXICITY

No instances of toxicity have been reported.

THREE /
Astragalus

COMMON NAME: Astragalus, milk-vetch root, or huang qi

BOTANICAL NAME: *Astragalus membranceus*

MAJOR USES

- Immunodeficiency
- Cancer
- Heart Disease
- Kidney Diseases
- Liver Disease

BACKGROUND

Traditional Chinese Medicine pays close attention to the strength of a patient's general resistance against illness. This invisible protective shield is known in traditional Chinese Medicine as the *wei chi* or one's protective energy. Since ancient times, the Chinese have relied on the delicate weed astragalus for strengthening the flow of *chi* energy through the spleen and strengthening resistance to the "winds" of illness, as the Chinese sometimes explain what we call bacteria, viruses, and other pathogens, toxins and causes of poor health.

Astragalus was first found in the Shanxi, Heilongjiang, Gansu and northern regions of China, and Inner Mongolia. Now, it is prevalent in parts of Turkey, Syria, Lebanon, and northwest Iraq. Its earliest use dates back to the *Divine Husbandman's Classic of the Materia Medica*, of the later Han Dynasty before 1000 A.D. It is now gaining attention in the United States as herbalists, researchers, and medical doctors have begun to recognize this herb's ability to support immune health.

Astragalus is an herb with a wide range of applications ranging from immune resistance to cancer. Current research and study of its therapeutic value in immune diseases, particularly for cancer prevention and during its treatment, is extremely exciting. Use this valuable herb whenever

you feel that you need additional protection against bacteria, viruses, and other pathogens in your environment.

Immunodeficiency

Astragalus can help raise the overall healthy activity of the immune system, particularly by raising white blood cell counts in people with chronic low white blood cell levels. Astragalus extracts have also been shown to be helpful in treating viral infections, including use as a preventive measure against the common cold. In particular, the herb has been shown to reduce the duration and severity of cold symptoms.

Cancer

Astragalus appears particularly useful in cases where the immune system has been damaged by chemical toxins or radiation, as in the case of people undergoing chemotherapy or radiation treatment. Patients undergoing conventional cancer therapy who use astragalus tend to maintain better immune health or a stronger wei chi, recover faster, and live longer. In a 1997 publication from the American Cancer Society, researchers reported that astragalus restored immune function in ninety percent of cancer patients studied. Astragalus may work by lessening bone marrow suppression and gastrointestinal disturbances, strengthening the body, and helping it assimilate protective nutrients from the diet.

Astragalus also works by improving the body's protective armor. The herb doesn't cause the body to attack cancers themselves but strengthens its immunity against the toxic cells that already reside in the body.

Heart Disease

It's no mystery that heart health can be obtained through proper lifestyle choices. But when heart disease is a concern, consider the healing benefits of astragalus. This cardiovascular tonic dilates blood vessels, improves blood circulation to the skin, and helps to normalize heart function and lower blood pressure.

Kidney Diseases

Cleansing the kidneys is paramount if you are to obtain optimum health. High concentrations of calcium, uric acid, and other substances in the urine can lead to the formation of kidney stones. Experimental studies

show powdered astragalus not only has a diuretic action but helps to reduce risks of protein build-up in the kidneys and reduces damage to the tissues in cases of kidney disease.

Liver Disease

In today's environment, people are exposed to a variety of environmental toxins, including agricultural chemicals, air pollutants, and substances from many other industrial sources. Astragalus has been shown to help protect liver function during periods of high exposure to chemical toxins.

Astragalus is available as a tincture, fluid extract, dried root powder or powdered extract. A standardized quality powdered extract, when properly selected and handled, however, will generally provide the most therapeutic results.

Be sure to always select the root portion of the plant, which possesses the strongest medicinal powers. Seek extracts that are standardized to contain .5 percent minimum of the isoflavone 4' hydroxy 3' methoxy isoflavone 7-SUG (GHMIF).

WHAT TO LOOK FOR

Take the equivalent of one 250 to 500 mg capsule three times daily with meals.

RECOMMENDED DAILY DOSAGE

Astragalus has no known toxicity even at the very highest therapeutic dosages.

TOXICITY

FOUR /
California Poppy

COMMON NAME: California poppy

BOTANICAL NAME: *Eschscholzia californica*

MAJOR USES

- Anxiety
- Insomnia
- Pain

BACKGROUND Anxiety is a normal condition everyone experiences at one time or another. In its natural state it can actually be useful when it motivates us to purposeful action. But in today's world where there is more information and activity than can healthfully fit into one twenty-four hour period, we often find ourselves in a state of anxiety that is harmful to both peace of mind and physical health.

Anxiety can range from mild, moderate, to severe or panic. As the state of nervousness or anxiety builds, the body is forced to respond. For some, it may begin with heart palpitations and an awful choking feeling that accompanies feelings of impending doom. One of the long-term effects of chronic anxiety is muscle tension and overall fatigue that accompanies being on one's toes day in and day out.

For some, the most stressful time of day is when others put their worries to rest. An estimated forty percent of adults in the United States reportedly have difficulty sleeping. And over five million people turn to sleeping pills in search of a good night's sleep. Now, there is a safer, more effective way to soothe the body's response to anxiety and insomnia.

The common California poppy may hold a promising answer. This brilliant yellow and orange flowering perennial with lacy gray green leaves

was used medicinally by West Coast Indians as a pain reliever. California poppy grows wild in grassy areas and dunes, lighting up hillsides and valleys on the west slopes of mountain ranges from southern California to southern Washington. Before development encroached upon its habitat, sailors relied on the brightly colored hillsides to guide their course.

All parts of this plant were used by Native Americans for culinary and medicinal purposes. The seeds were gathered for use in cooking, both whole and ground for their oil. The leaves, stems, and flowers were used medicinally in teas, poultices, and tinctures for the treatment of toothaches, headaches, colic and skin sores. Contemporary applications of California poppy, however, primarily center on its use as a gentle, non-addictive sedative and analgesic. While North American scientists may have overlooked this popular garden poppy, for years European scientists in the field of phytomedicine have had a keen interest in this plant for its medicinal properties.

MAJOR USES DEFINED

Anxiety

The sap of California poppy contains sedative alkaloids which have the beneficial qualities of its oriental poppy cousin without the addictive qualities. This humble little herb packs powerful active components: protopine, cryptopine, chidonine, sanguinarine, marapine, chelerythrine, chelirubine, isoquinoline alkaloids, rutin, and flavone glycosides. It is the isoquinoline alkaloids which have been most researched in the last few years for their sedative effect on the body.

California poppy has been tested for its ability to diminish the effects of anxiety and was found to slow motor activity in animals. In humans, it is this bioactive property that provides relief of jittery nervousness, pacing, and hypersensitivity. In one study, California poppy was found to have a positive effect on specific compounds in the body which control the nervous and cardiovascular systems in times of anxiety. This accounts for California poppy's sedative, antidepressive, and hypnotic activities.

Insomnia

In France and Germany, California poppy is prescribed as a sedative. It has been found effective in the treatment of insomnia brought on by nervousness, as well as conditions of agitation or anxiety. Isoquinolines, one of California poppy's bioactive components, cause relaxation and an amiable lethargy.

Pain

California poppy also has a reputation as a pain reliever. Recent research shows its potent active ingredients, isoquinoline alkaloids, modulate neurotransmitter metabolism. Our body naturally produces brain chemicals which act as opiates in the body. Isoquinoline has been found to stimulate both the brain's production of these pain-relieving chemicals, as well as increase the period of time they are effective in the body.

It is clear that the medicinal properties of California poppy are only beginning to be understood. In the near future, this herb is likely to become as popular as many other herbal remedies for what is considered the distress of our time—nervousness, anxiety, and insomnia.

WHAT TO LOOK FOR

The stems, leaves and flowers of the plant may be used for their alkaloid-containing sap, though most commonly it is the leaves and flowers. In standardized herbal extracts it is important to look for a minimum of 1.8 percent isoquinoline alkaloids, as this is the active ingredient documented to provide gentle, but powerful relief from conditions associated with nervousness, anxiety and insomnia.

RECOMMENDED DAILY DOSAGE

Take the equivalent of one 300 mg capsule of the standardized herb twice daily or one hour before bedtime if used as a sleeping aid.

TOXICITY

None reported. However, avoid use during pregnancy due to lack of established studies confirming safety.

FIVE /
Cat's Claw

COMMON NAME: Cat's Claw

BOTANICAL NAME: *Uncaria tomentosa*

MAJOR USES

- Cancer
- Rheumatoid Arthritis
- Viral Infections
- Allergies
- HIV

BACKGROUND

Cat's claw has long been used by natural healing doctors of China, Malaysia, Thailand, and Burma to treat allergies, arthritis, inflammation, cancer and some viral infections. Recently it has made its way into our Western culture as a potent healing herb.

MAJOR USES DEFINED

Cancer

The history of cat's claw in cancer treatment has been one of intense interest and seeming disinterest. In the early 1970s, the National Cancer Institute began studying the active constituents of cat's claw bark and root. These studies demonstrated promising results in fighting leukemia, but then all research in the United States came to an abrupt halt. Research seemed to indicate that the whole root or bark was better than single isolated compounds. Without a key chemical to isolate and synthesize, commercial interest from pharmaceutical companies waned. Fortunately, at about that time, Peru's National Institute of Neoplastic Diseases began studying the plant's anticancer qualities and interest resurfaced.

Researchers at the Institute of Pharmacology at the University of Innsbruck, Austria, have long used a patented extract of the root bark called Krallendorn® for more than ten years in the treatment of certain types of cancer and several viral diseases.

101

A study by Wagner and colleagues at the Institute of Pharmaceutical Biology at the University of Munich, Germany, found that one of the alkaloids in the cat's claw preparation studied by the Innsbruck researchers was a "powerful stimulant of phagocytosis." The body's phagocytes ingest microorganisms and damaged cells in a process called phagocytosis.

In some cases immunological status has also improved. Fortunately, cancer patients can now purchase Krallendorn® in the United States under the trade name Saventaro® (see Resources).

Rheumatoid Arthritis

The cat's claw formula known as Krallendorn® in Europe and Saventaro® in the United States is one of the few natural medicines that we know of that has been clinically demonstrated to benefit rheumatoid arthritis. A double-blind study (that is completely compliant with German federally established guidelines) of 40 patients has shown significant improvement in the active treatment group versus the placebo group.

The study was conducted from 1994 to 1997 in forty patients with rheumatoid arthritis at the rheumatological outpatient department of the University Hospital of Innsbruck. Both treatment groups received disease-modifying therapy on demand with salazopyrine or plaquenil and analgesic therapy with NSAIDs and steroidal anti-inflammatory drugs.

The active treatment group also received the Krallendorn®/ Saventaro® cat's claw formula at a dosage of three capsules daily and the placebo group a dummy pill in the same dosage regimen. Duration of treatment was 24 weeks. The primary criteria of efficacy were the number of tender and swollen joints; severity of joint pain; and subjective assessment of the tenderness and swelling of the joints by the patient. Secondary criteria of efficacy were the degree of physical impairment; duration of morning stiffness; and changes in the surrogate blood markers, including rheumatoid factor. The results were impressive:

After six months of active therapy with the *Uncaria tomentosa* preparation, the number of tender joints was significantly lower in the active treatment group than in the placebo group.

Seventeen of the eighteen patients in the active treatment group had a decrease in joint pain and only one patient an increase compared with the baseline value. Of the seventeen patients in the active treatment group with a decrease in joint pain, fourteen had a regression of greater than or equivalent to 50 percent in the number of tender joints

and ten experienced regressions of greater than or equivalent to 75 percent. For five patients, the number of tender joints regressed completely. In the placebo group, only ten of the seventeen patients exhibited a decrease in the number of tender joints. Seven of the patients had an increase in joint pain.

The severity of pain also was significantly reduced in the active treatment group compared with the placebo group.

By the end of the six-month trial, the duration of morning stiffness was significantly shorter in the active treatment group than in the placebo group.

Rheumatoid factor at the study end-point of month six was significantly lower in the active treatment group than in the placebo group.

The results from this preliminary study provide good evidence that a natural medicine has demonstrated efficacy in the treatment of rheumatoid arthritis. Most heartening is the statistically significant improvement in the active treatment group patients in terms of the extent of joint pain and their decrease from on average of eight painful joints at the beginning of the study to an average of three painful joints at the end.

The decline in severity of morning stiffness from an average of 1.4 hours to an average of 0.7 hours was also significant, as was the decline in rheumatoid factor in the active group (and its increase in persons taking placebo). This latter finding could indicate a positive effect of the test medication on the pathological mechanisms underlying rheumatoid arthritis.

Viral Infections

In a study of antiviral activity, cat's claw extracts were shown to be effective against viruses found in the digestive tract, as well as the upper respiratory tract.

Allergies

When taken orally, the Krallendorn® formula reduced the allergic symptoms in patients with allergic respiratory diseases such as rhinitis and asthma.

HIV

Krallendorn® has also been tested in patients with HIV infection. The body's T-lymphocytes, which are responsible for cellular immune function, were increased in these patients. As a consequence, these individuals were less susceptible to infections and their general state of health improved.

WHAT TO LOOK FOR

Since 1974, a young and inquisitive journalist from Austria has studied various species of cat's claw and their potential contribution to medicine. Klaus Keplinger has found that some species of cat's claw may be immunologically ineffective.

Uncaria Tomentosa includes two chemotypes, pentacyclic oxindole alkaloids and tertracyclic oxindole alkaloids. The first (pentacyclic oxindole alkaloids) enhances the mechanism of T and B-lymphocytes, which positively modulate immune function. The second (tertracyclic oxindole alkaloids) inhibits the aggregation of white blood cells, may lower blood pressure, and appears to have an effect on the central nervous system. When combined, these two components may make cat's claw far less effective.

This is critical information for herbal manufacturers who tie their cat's claw products to various health-related claims. What's more, for consumers who rely on cat's claw as a healing herb, they may want to scrutinize the product they are using. Keplinger analyzed some fifty cat's claw products from the United States, Central America and Peru and found varying degrees of pentacyclic and tetracyclic alkaloids.

Keplinger and his team have found a way to isolate only the immunostimulating pentacyclic chemotype of cat's claw. In doing so, his preparation of cat's claw is proven more effective in treating chronic urinary tact infections, herpes simplex, rheumatoid arthritis, HIV, and some forms of cancer. Marketed in the United States under the trademark, Saventaro®, this brand of cat's claw contains 99 percent pentacyclic oxindole alkaloids. Because the concentration of active contents may vary from plant to plant, it is extremely important to select only products that have had their alkaloid content measured and that contain pentacyclic oxindole alkaloids. See Resources for information on obtaining my recommended Saventaro® formula.

RECOMMONDED DAILY DOSAGE

Take one capsule three times a day for the first ten days, then one to three capsules daily depending on your continued response.

TOXICITY

Avoid use with very young children under age five, as little is known about its possible effects on children. Bone marrow transplant patients should avoid use of this product for at least one year after the transplant. In addition, avoid use if any organ transplants are planned. Do not use this herb if you are taking immune-suppressing drugs. And if you plan to use the herb in addition to chemotherapy, avoid taking it two days before and two days after treatment.

SIX /
Coleus Forskohlii

COMMON NAME: *Coleus forskohlii*

BOTANICAL NAME: Same

MAJOR USES

- Heart Disease (including high blood pressure)
- Asthma
- Psoriasis

BACKGROUND

Coleus forskohlii, long used in Ayurvedic medicine, is a member of the mint family, native to mountains of India, Nepal, Sri Lanka, Africa, Burma, and Thailand. It is usually found at altitudes of up to 6,000 feet. This aromatic plant bears spiked, blue-lavender flowers. The tubers, which are thick and twisted, are commonly used in pickles and condiments. These tubers also have a medicinal use, as they contain unique compounds that provide support for those suffering from heart disease, hypertension, asthma, and psoriasis.

Coleus forskohlii has two active compounds bearing quite similar properties, coleonol and forskolin. It is forskolin that has thus far been subject to the most scientific research. Interestingly, forskolin, found only in the tubers of this plant, has been widely researched in over five-thousand studies investigating its ability to stimulate the body's optimum cellular regulation.

Proper cell function is imperative for one's good health. Research has established that when the body is suffering from disease it is compromised in its cellular activity. In particular, an important cell regulator, cyclic adenosine monophosphate or cAMP, is found at very low levels.

105

Once cAMP is formed in the body it is responsible for the regulation of numerous cellular functions. This increases the body's ability to stave off depleting conditions associated with chronic disease. What is so amazing about forskolin is its extraordinary ability to activate the body's level of cAMP. In fact, some studies show increases of up to four-hundred fold!

Countless research studies have demonstrated forskolin's unique ability to encourage the body's optimum level of cAMP. Together with forskolin's ability to positively act upon various systems within the body, this highly underrated herbal medicine is a versatile healer with proven benefits for heart disease, asthma, and psoriasis.

While much of the research that brought *Coleus forskohlii* into medical limelight has been done with the isolated compound of forskolin, it is believed that the plant holds additional components which may enhance the absorption and biological activity of forskolin.

MAJOR USES DEFINED

Heart Disease

Ayurvedic medicine recognized *Coleus forskohlii's* powerful attributes long before modern scientists isolated its constituents responsible for defense against heart and respiratory disease. Today, forskolin is a most promising medicine in the treatment of conditions that lead to congestive heart failure. Current pharmaceutical therapies rely on medications that widen clogged blood vessels or reduce blood clotting factors and lower blood pressure. These medications are not without side effects, and individuals often develop a tolerance for such drugs rendering them ineffective. Rather than blocking body functions, coleus activates proper cellular enzyme response, via cAMP modulation allowing the heart to operate more efficiently.

Coleus may be very helpful in cases of congestive heart failure. Many studies have been undertaken to further understand the activity of forskolin in the fight against heart disease. Along with lowering blood pressure, it has the ability to increase the heart's capacity to fully contract. The increased cAMP levels have a relaxing effect on arteries, thereby increasing the force of contraction. In conditions associated with congestive heart failure, the heart muscles cease to pump efficiently. This is usually due to damage to the heart muscle or valves of the heart controlling the flow of blood. Forskolin has been researched in numerous heart studies due to its powerful effect on the muscle of the heart. In one study,

seven patients whose heart muscles were not able to function fully were given forskolin and experienced improved left ventricular chamber function. In another clinical study, in which forskolin was found to possess essential beneficial properties in the treatment of congestive heart disease, participants experienced reductions in blood pressure, including systolic, diastolic and pulmonary artery pressures.

Medical research continues on the application of this vital plant in the treatment of heart disease and other conditions known to respond to healthy cAMP levels. Forskolin is a likely model candidate for drug manufacturers. It holds a promising future as an isolated compound, much like digitalis, which was brought forth from the plant kingdom and into modern medicine.

Asthma

Coleus forskohlii may also be used in the treatment of asthma. Forskolin has an antispasmodic action on various smooth muscles in the body, including the respiratory tract. This property, based on its ability to increase cAMP levels, offers asthma sufferers a powerful herbal treatment option. As a potent bronchodilator, forskolin has been found effective in bringing relief to the symptoms that are so troublesome. While current asthma drug therapies seek to increase cAMP levels by inhibiting enzymes which break down cAMP once it is formed, forskolin actually builds up cAMP levels, promoting relaxation in the bronchial muscles. Researchers have investigated the use of an aerosol form of forskolin, available in Europe, for use in severe asthma attacks requiring immediate relief. The dilating actions of forskolin upon the bronchial airways were found to have a positive effect in these conditions.

Psoriasis

In cases of the common skin disorder psoriasis, skin cells begin dividing wildly—at rates of up to one-thousand times the normal rate. This occurs due to an imbalance in the relationship between two cell-regulating compounds, cAMP and cyclic guanin monophosphate (cGMP). Forskolin has been found to have a regulating effect on these two compounds bringing much needed relief to those suffering from symptoms related to psoriasis. In addition, forskolin posses anti-allergy activity which inhibits the release of histamines. This results in a beneficial reduction in psoriasis-related swelling and inflammation.

WHAT TO LOOK FOR Forskolin should be taken orally in extract form. It is best to use a standardized extract of *Coleus Forskolii* guaranteed to provide up to 18 percent forskolin and that yields 9 mg of the active ingredient per capsule. Very few companies are producing such high quality extracts. Be sure to check Resources for information on how to obtain a quality *Coleus Forskolii* extract.

RECOMMENDED DAILY DOSAGE Take one 50 mg capsule of the standardized herb twice daily with meals.

TOXICITY No toxicity study has been conducted on the whole plant, but it should be avoided by gastric ulcer patients and those with low blood pressure. *Coleus Forskolii* has the ability to potentiate effects of other drugs. Therefore, it should be used cautiously when taken with prescription medications.

SEVEN /
Gold Thread

COMMON NAME: Gold Thread

BOTANICAL NAME: *Coptis chinensis* (Huang Lian in Traditional Chinese Medicine)

MAJOR USES
- Infection
- HIV/AIDS
- Rheumatoid Arthritis

BACKGROUND

Found throughout regions of China, the roots of gold thread have a bird claw appearance with small, branching yellow-brown coarse hairy tubers. The root of gold thread has long been regarded as a vital medicine for cleansing the body and removing toxins from the tissue. Gold thread was a cure-all in Chinese medicine used for treatment in conditions as varied as fever, dysentery, chest complaints and eye conditions. Contemporary exploration of its medicinally useful compounds have broadened its range of application. Recent studies show it to be a promising treatment for HIV/AIDS as well as rheumatoid arthritis.

Infection

MAJOR USES DEFINED

Gold thread's most powerful active compound is berberine, a potent anti-bacterial substance that has been proven to be highly efficacious both in clinical settings for treatment of common infectious diseases and experimentally for its ability to attack microbial pathogens. Berberine's strong anti-bacterial and anti-parasitical properties can help to inhibit those particular microbes responsible for strains of pneumonia, meningitis and staphylococcus infections. Gold thread inhibits dysentery even more

effectively than sulfa drugs. Gold thread not only relieves patients of the fever associated with such conditions, its bioactive compounds are also able to attack the very microbes responsible for the infection.

HIV/AIDS

Perhaps the most notable of gold thread's recent acclaims is its strength as an anti-viral agent. Gold thread may hold a key for treatment of HIV/AIDS. It was one of 11 traditional Chinese herbal extracts tested for their anti-HIV effect. Along with arctium, epimendium, lonicera, woodwardia, viola, senecio, andrographis, pruinella, lithospermum and alter-manthera—gold thread was found to reduce the percentage of cells positive for HIV/AIDS antigens *in vitro* (i.e., in the test tube).

Rheumatoid Arthritis

Gold thread has also shown promise as an anti-inflammatory treatment for rheumatoid arthritis, an autoimmune disease in which the body's immune system attacks its own tissues. The pain associated with this disease is due to inflammation of the thin membrane surrounding affected joints. While the body relies on inflammation to remove or dilute injurious materials, in cases of rheumatoid arthritis, white blood cells continue to accumulate in the affected area due to impaired metabolic processes. Gold thread's anti-inflammatory properties inhibit further production of white blood cells in the joint area, providing the body an opportunity to prevent their accumulation and effectively reduce inflammation and swelling.

WHAT TO LOOK FOR

Gold thread is grown throughout China and has minor changes in its name to indicate the region of origin. The best root is said to come from the Szechwan Province. Chinese herbalists consider the more brittle roots to have stronger medicinal properties. For those of us who do not have the opportunity to shop in traditional Chinese pharmacies, you will want to look for a product containing high levels of berberine. Standardized products that provide at least 25 mg of berberine alkaloids per capsule or tablet are most effective in the treatment of infection and rheumatoid arthritis.

Take one to two 250 mg capsules or tablets of the standardized herb three times daily.

RECOMMENDED DAILY DOSAGE

No toxicity has been reported.

TOXICITY

EIGHT /
Gotu Kola

COMMON NAME: Gotu kola

BOTANICAL NAME: *Centella asiatica*

MAJOR USES

- Burns
- Keloids
- Cellulite
- Venous Insufficiency
- Ulcers of the Lower Limbs/ Varicose Veins
- Post Partum Discomfort
- Cirrhosis

BACKGROUND

Do you have surgical scars that won't heal? Do you have other types of skin problems? Then, gotu kola may be an important herb for you to know about. Scientific research demonstrates that skin blemishes, psoriasis, eczema, and even varicose veins can be improved by taking advantage of this little known blood purifier and skin nutrient.

Gotu kola, a broad-leafed perennial herb with red flowers and round, kidney-shaped leaves, forms fruit throughout its growing season. This hardy, adaptive plant is native to India, China, Indonesia, Australia, Madagascar, and the South Pacific, as well as the southern and mid-latitude regions of Africa.

Gotu kola has been used both topically and orally in India and Java for its ability to heal both wounds and leprosy. In fact, gotu kola has been used in India as a healing medicine since prehistory. It has been recorded for use well beyond the Indian subcontinent. For example, it is considered a premiere longevity herb in Chinese medicine, where it is widely used to delay the pains of growing old.

In the late 19th Century, French physicians adopted gotu kola as a medicine for patients complaining of skin conditions. Its use has continued and spread throughout Europe and now the United States with good reason: Gotu kola's medical validation is strong and solid with amazingly

112

positive results for hastening wound healing and normalizing varicose veins, skin ulcers, eczema, and psoriasis.

Compounds found in this perennial herb include the triterpenoids, asiatic acid, madecassic acid, asiaticoside, and madecassoside. Gotu kola is also rich in volatile oil compounds including essential oils of camphor and cineole, as well as others that have not yet been identified. Its other important chemicals are plant sterols such as campesterol, stigmasterol, sitosterol, flavonoids, quercetin, sugars, and amino acids.

Gotu kola may contain different chemical ratios depending on the region where it is found. Do not expect gotu kola from Sri Lanka to be chemically identical to that of Madagascar or India. Several varieties of gotu kola with distinctly different chemical compositions grow in India alone. Variations such as these make it a truly difficult plant to gather and process for uniform results. This makes standardization all the more important.

How does gotu kola exert its remarkable wound healing effects? Studies show it helps the body to maintain healthy connective tissues by maintaining the vessels that enable the blood to reach them. Gotu kola also helps the body manufacture structural substances such as hyaluronic acid, a viscous medium in the body, and chondroitin sulfates which also help to impart shape to the body's structural tissues. In addition to these pharmacological properties, gotu kola stimulates healthy skin metabolism and the manufacturing of healthy keratin, the tough insoluble protein that makes up our hair, nails, and outer layer of our skin. At the same time, gotu kola's effects on fibroblasts which contribute to the formation of connective tissues helps to reduce sclerosis or hardening of the skin.

Today, gotu kola is a medically validated wound healing agent that is documented to aid in the healing of burns, keloids, cellulite, cirrhosis of the liver, and leprosy. It is also useful for scleroderma, vein disorders, and wound healing.

Burns

MAJOR USES DEFINED

Studies have shown that second and third degree burn patients improved remarkably if they received either topical applications or intramuscular injections of gotu kola immediately following scalding by boiling water, electricity, or gas. Indicators of improvement include less swelling, skin loss, and scarring, fewer infections and faster healing.

Keloids

The proliferation of abnormal scar tissue on surgical wounds (keloids) has long been considered both blemishing and potentially painful if inflammation continues unabated. Gotu kola has shown impressive results in healing keloids. Gotu kola's effects are dual: it reduces inflammation while enhancing skin healing.

In one study, published in 1979 in the *Annals of Plastic Surgery*, gotu kola extract was of enormous help to same 227 patients whose surgical wounds were not healing well and helped to rapidly reduce symptoms and inflammation. The study also found that use of gotu kola three weeks before surgery and lasting for three months following surgery also was extremely helpful in more than 75 percent of patients.

Cellulite

Men and women with cellulite, lumpy fat deposits in their thighs and buttocks, will find gotu kola to be especially beneficial. A review of many of the major studies on cellulite shows that about 80 percent of patients who use gotu kola for at least three months achieve satisfactory to excellent reductions.

Its use to remove cellulite is widely reported among European women but, unfortunately, not yet widely known to most Americans. In one three-month study, gotu kola or a placebo pill was given to cellulite sufferers. A significantly reduced tendency of hardening and pocketing (sclerosis) occurred in those receiving gotu kola compared to the placebo group.

Venous Insufficiency

Do you ever feel a heaviness in your lower legs, tingling, or suffer nocturnal cramps? Many people have circulatory problems in the legs at one time or another, also known as venous insufficiency. Again, gotu kola may be extremely helpful. Gotu kola improves the structural integrity of the veins, reduces hardening, and improves blood flow.

In one study reported in 1975, 89 percent of 61 patients receiving oral gotu kola achieved excellent or good results. In 1982, Drs. Mazzola and Gini used oral gotu kola with patients suffering edema of their lower limbs, skin damage, and ulcers. After 30 days of treatment, all patients demonstrated significant improvement. Many additional studies support the use of gotu kola in cases of venous insufficiency with about 80 percent of patients showing significant improvement.

Ulcers of the Lower Limbs/Varicose Veins

Closely related to venous insufficiency, ulcers of the lower limbs are often associated with poor circulatory health. The body's veins are responsible for returning blood to the heart from the tissues. Unfortunately, the aging process, coupled with the strain imposed on the valves in the leg veins by our upright posture, takes its toll on our veins. When the walls or valves of the veins become damaged, this can dramatically inhibit their ability to return blood to the heart, causing the blood to back-up. These pockets of pooled blood cause the bulging blue raised veins known as varicose veins. These usually occur at the back of the calf or up the inside of the leg almost anywhere between the ankle and groin.

Except in rare cases when ulcers, clots or infections occur, varicose veins are usually more annoying than disabling. Still, people's concerns are equally split between the cosmetic marring that these unsightly, bulging veins near the surface cause and actual painful swelling in their legs.

Drs. Boely and Ratsimamanga in 1958 were among the first researchers to describe good results obtained with gotu kola in their patients with lower limb ulcers. In 1960, Dr. Farris began using intramuscular gotu kola with fifteen patients who were suffering venous circulation problems and ulcers. The patients' previous treatments produced disappointing results, but with gotu kola all patients demonstrated significant improvement. In another study published in 1962, patients given gotu kola experienced disappearance of their ulcers within days, shedding of damaged tissues and clean wound healing. Intense, active formation of new tissue was seen. Even the eczema around the ulcers healed quickly. Studies in the 1970s and 1980s further confirmed these amazing results in patients with ulcers of their lower limbs.

Post Partum Discomfort

For many women, along with the excitement and exhaustion of childbirth, comes the lingering pain of an episiotomy. Gotu kola has proven to ease this post partum discomfort and promote rapid healing. In 131 women, following childbirth with episiotomy, gotu kola worked in 121 of the cases and supplied good or very good results in 106. Healing was swift with little residual pain. Consistently good results show women should use gotu kola immediately to stimulate a faster healing process.

Cirrhosis

Gotu kola is not generally known by health professionals to be helpful in alcohol-related problems, but in one small study it proved promising in a limited number of alcoholics with liver damage, as well as for a few other patients whose cause of liver disease was not known (i.e., idiopathic). Among its positive effects on liver tissue was reduced inflammation.

WHAT TO LOOK FOR

Gotu kola may be harvested at all times of the year. All portions of the plant are useful medicinally. However, because of the geographic variability in its active constituents, the standardized form from Madagascar should be used. For reliable results and assurance of quality, seek a laboratory-certified brand.

The consensus recommendation on gotu kola extract is one with tripterpene concentrations of 29 to 30 percent asiatic acid; 29 to 30 percent madecassic acid; up to 40 percent asiaticoside; and, one to two percent madecassoside.

Gotu kola is used intramuscularly, topically or orally. For most consumers, the standardized oral extract is the best and most reliable choice.

RECOMMENDED DAILY DOSAGE

Take one to two 60 mg standardized capsules daily.

TOXICITY

Occasionally, topical applications may cause contact dermatitis.

NINE /
Gymnema sylvestre

COMMON NAME: *Gymnema sylvestre*

BOTANICAL NAME: Same

MAJOR USES
- Adult Onset / Juvenile Diabetes

BACKGROUND

Deep in the tropical forests of Central and Southern India grows a small, woody plant that holds great promise for diabetes sufferers. For over 2000 years, *Gymnema sylvestre* has been studied extensively and used in the treatment of diabetes mellitus. In 6th Century B.C., the well-known surgeon Sashruta studied the effects of Madhu-meha, as the herb was referred to then, and recorded positive results in the Indian *Materia Medica*. For decades, Indian practitioners turned to this herb to help control blood sugar. Then in 1930, use of the herb spread throughout Europe when western doctors investigated the hypoglycemic effects of this herb and found it to be effective. Since this time, scientists have puzzled and marveled over this climbing vine's medicinal properties.

MAJOR USES DEFINED

Adult Onset / Juvenile Diabetes

Sugar is the primary fuel for the body. Sugar governs alertness, mood, and our mental powers. Every cell in the body needs sugar. The body's need for sugar is instinctual and genetic. Sugar, when not properly absorbed by the body's cells, however not only ends up starving the cells; it is a blood poison. Diabetics know this all too well.

Adult-onset diabetes is fast becoming a common problem in the United States. In fact, estimates indicate that every sixty seconds, someone in America is diagnosed with this disease.

There are two major forms of adult-onset diabetes: Type I and Type II. Type I (insulin-dependent diabetes) describes people who do not produce insulin and accounts for about 700,000 cases, or five to ten percent of all diabetes.

Type II diabetes accounts for 90-95 percent of all cases and is nearing epidemic proportions. People with Type II diabetes have disrupted insulin activity due to one of two conditions. The first condition is due to reduced beta cells in the pancreas which are responsible for producing insulin. In the second condition, the pancreas is producing adequate amounts of insulin, but the cells of the body have become insensitive to insulin or are "insulin resistant."

The onset of adult diabetes is slow in the beginning. Symptoms are mild, insidious, almost unnoticed and include frequent urination, sometimes as often as every hour, and feeling extremely tired, weak, and apathetic. Other symptoms include tingling in the hands and feet, and reduced resistance to infection, blurred vision, and impotence. Women may experience the absence of menstrual periods. The most likely candidates for Type II diabetes are overweight adults over 40 years of age.

Diabetes must be kept under control to avoid long-term complications such as atherosclerosis, nerve degeneration, blindness, and even gangrene. Fortunately, people with adult onset diabetes can do a great deal to help themselves. The key is diet and nutrition.

Nutritional support is extremely important. A nutritional program should address the potentially damaging complications from diabetes with antioxidants that can reduce arterial and nerve damage. Support for the body's sugar metabolism process and revitalization of the body's glandular system should also be part of one's daily health regimen. *Gymnema sylvestre* is an excellent herbal protector, capable of addressing these nutritional needs. When taken orally, this herb has been proven to favorably regulate blood glucose levels for Type I and Type II diabetes sufferers.

In India, this herb is called gurmar, which means sugar destroyer. However, its more appropriate moniker might be sugar modulator. *Gymnema sylvestre's* principal constituent, GS4 (a water-soluble extract of the leaves), enhances insulin activity. In one study, GS4 was given to

patients with insulin-dependent or Type I diabetes. Over time, the GS4 effectively reduced fasting blood glucose levels, lowered serum cholesterol and tryglyceride levels, and improved serum protein levels.

For Type II diabetics, *Gymnena sylvestre* may be a welcome relief. An extract of the herb was given to diabetic patients on oral hypoglycemic medicine. After eighteen to twenty-two months, all patients reported a reduction in blood glucose, glycosylated hemoglobin, glycosylated protein, and increased insulin levels.

A gymnema extract should be standardized to contain 75 percent gymnemic acid.

WHAT TO LOOK FOR

Take one 200 mg capsule of the standardized herb two to three times daily.

RECOMMENDED DAILY DOSAGE

Blood glucose monitoring should be carefully administered by a trained physician. If you are taking insulin or oral hypoglycemic drugs, work with your doctor before using this herb.

TOXICITY

TEN /
Horse Chestnut Seed

COMMON NAME: Horse Chestnut Seed

BOTANICAL NAME: *Aesulus hippocastanum*

MAJOR USES
- Venous Insufficiency (Varicose Veins)
- Hemorrhoids
- Hematomas

BACKGROUND

We know what a poor diet and lack of exercise can do to our waistline, but how do lifestyle choices affect our circulation—specifically our venous system? With today's fast-food, exercise-absent lifestyles, more individuals are developing varicose veins, cellulite and hemorrhoids than ever before. Fortunately, nature's medicine chest holds great promise. Throughout Europe, an extract of horse chestnut seed is used successfully as a safe, effective treatment for varicose veins, hemorrhoids, and leaky vessels.

The decorative horse chestnut tree can grow one-hundred feet tall, and boasts a forty-foot diameter. Its bright green spring leaves and large brown seeds formed in autumn are used in prepared extracts. The tree is a native of Western Asia, but it can be found throughout Asia Minor, Europe, and the United States. As early as 1651, researchers recognized the medicinal value of this plant. Herbal doctors of the 19th century used horse chestnut for people with engorged blood vessels and leg pain. Today, scientists have clinically validated horse chestnut's ability to act on the connective tissue barrier between blood vessels and tissue where veins become permeable.

The two active constituents found in horse chestnut, aesuline and aescin, are saponins. These powerhouse phytochemicals cleanse and stimu-

late vessel strength, repair leaking capillaries, and promote excess body fluids to return into the bloodstream for elimination or recirculation.

Venous Insufficiency (Varicose Veins)

MAJOR USES DEFINED

Varicose veins are the most common of venous system diseases. The condition appears to increase with age and shows little gender bias. If left untreated, varicose veins can lead to leg eczema and ulcers. Occasionally, symptoms of this disease can lead to hospitalization and/or early retirement.

Conventional treatment for varicose veins includes compression bandages and stockings, surgically stripping affected veins, or injections of sodium chloride. These procedures tend to relieve symptoms, but too often the dreaded bulging veins reappear.

Horse chestnut extract allows cells lining the veins to better tolerate a lack of oxygen. This breaks the vicious circle of venous insufficiency, leading to less inflammation, less swelling, and fewer white blood cells accumulating. In theory, use of horse chestnut seed should also lead to less vein growth and fewer varicose veins, though this has not been tested directly.

The enzyme hyaluronidase increases permeability of the veins, which promotes further venous insufficiency. Hyaluronidase also facilitates growth of the smooth muscle cells, which contribute to varicose veins. Horse chestnut's escin inhibits hyaluronidase.

The scientific evidence that supports escin is very strong. To assess evidence for or against horse-chestnut seed extract (HCSE) as a symptomatic treatment of chronic venous insufficiency (CVI), researchers from the Department of Complementary Medicine, School of Postgraduate Medicine and Health Sciences, University of Exeter, United Kingdom, reviewed much of the published double-blind, randomized controlled trials of oral horse chestnut extract for patients with CVI. They concluded, "The superiority of [horse chestnut seed extract] is suggested by all placebo-controlled studies. The use of HCSE is associated with a decrease of the lower-leg volume and a reduction in leg circumference at the calf and ankle. Symptoms such as leg pain, pruritus, and a feeling of fatigue and tenseness are reduced.... One trial suggests a therapeutic equivalence of HCSE and compression therapy. Adverse effects are usually mild and infrequent. These data imply that HCSE is superior to placebo and as effective as reference medications in alleviating the objective signs and subjective symptoms of CVI. Thus, HCSE represents a treatment option for CVI that is worth considering."

The goal of varicose vein treatment is to increase capillary integrity and reduce edema (painful swelling). Fortunately, aescin, the main constituent in horse chestnut has an anti-edema effect. In a placebo-controlled clinical study, 240 patients with chronic venous insufficiency were divided into three treatment groups: compression therapy, horse chestnut seed therapy and placebo. After twelve weeks, researchers reported that both those receiving compression therapy and horse chestnut seed therapy experienced a 25 percent reduction of edema volume, or swelling. According to the researchers, "Because compression therapy treatment is uncomfortable and subject to poor compliance, horse chestnut seed therapy for chronic venous insufficiency offers an acceptable alternative."

Additional Help for Edema and Chronic Venous Insufficiency

The addition of curcumin-rich turmeric should also help to inhibit growth factors that enable the cells of the veins to continue to grow and lose more integrity. Grape seed extract helps to restore the integrity of the veins.

I recommend that anyone seeking to improve the appearance of their veins definitely use Grape Seed Phytosome™. Each capsule provides 100 milligrams of grape seed extract bound to phosphatidylcholine for highly enhanced absorption. Take one to three capsules daily with meals. Turmeric should be standardized to provide 95 percent curcuminoids. (See Resources for my recommended grape seed formula.)

Hemorrhoids

Painful hemorrhoids, often a symptom of constipation, are actually a form of varicose vein. Horse chestnut seed's ability to work as a blood vessel tonic accounts for its effectiveness in hemorrhoid conditions. Specifically, aescin helps repair blood vessels that break easily or are stretched out—common hemorrhoid symptoms. When applied topically, horse chestnut works as an astringent to stop minor bleeding and discomfort associated with hemorrhoids.

Hematomas

Do you recall when giving blood you occasionally developed a painful bruise and swelling at the injection site? This is referred to as a hematoma. Hematomas may also develop as a result of trauma during sports or exercise. Medicine made from horse chestnut is now used wide-

ly in Europe to reduce the pain of hematomas. The renowned Bastyr University in Seattle, Washington, conducted a trial to demonstrate the effectiveness of a horse chestnut gel, specifically its active agent aescin, in treating hematoma tenderness. Out of 71 trial participants, all reported a significant decrease in tenderness and pain after a single preparation of the aescin gel.

WHAT TO LOOK FOR

Be wary of confusing horse chestnut with sweet chestnut (*casanea vesca*). These nuts are delightfully edible but contain no medicinal value.

A key active constituent of horse chestnut is aescin. Therefore, look for a laboratory-certified product standardized to 20 to 22 percent saponins calculated as aescin.

RECOMMENDED DAILY DOSAGE

Take one 250 mg capsule two times daily with meals.

TOXICITY

Horse chestnut extract is approved as an over-the-counter phytomedicine in Germany and is widely used to support circulatory health. Horse chestnut seed is safe and well-tolerated.

ELEVEN /
Khella

COMMON NAME: Khella or bishop's weed

BOTANICAL NAME: *Ammi visnaga*

MAJOR USES

- Asthma
- Angina
- Kidney Stones

BACKGROUND

Do you suffer asthma, angina or kidney stones? Then the little known herb khella, long known for its medicinal properties in Egypt, may become your best friend. A native plant in the Mediterranean and low lands of Egypt and Morocco, khella was recognized and used as long as four-thousand years ago by the Egyptians for cases of asthma and heart disease. It is only now being re-established in the world's natural healing *Materia Medica*.

Khella's flower stalks and pedals are all nearly equal in length and spread from a common center. The stalks are thin enough to be used as toothpicks. The plant's appearance is similar to carrots or celery with a pleasant, slightly spicy taste. Khella is now cultivated in Egypt, the United States, Mexico, Chile, and Argentina. Its major chemical constituents are known as khellins, visnadins, and pyranocumarines.

Historically, khella was used for a wide range of conditions including whooping cough, angina, stomach cramps, painful menstruation, and intestinal parasites (worms). Today, the most well documented uses are for asthma, angina, and kidney stones. The theme in its numerous applications appears to be its role as an extraordinarily effective smooth muscle relaxant with a corresponding wide range of related functions in the human body.

Asthma

Khellins, one of the active chemicals of khella, are bronchodilators and antispasmodics. These compounds make khella extremely useful to people who suffer asthma. Herbalists, however, recommend its use to prevent rather than to counter asthma attacks.

Khella is nonstimulating and does not deplete vigor. In fact, khella is a possible substitute for another well known herbal asthma aid ma huang (ephedra or ephedrine), which may be contraindicated in people with high blood pressure or glaucoma.

MAJOR USES
DEFINED

Angina

Many clinical studies on khella validate its use in angina, a sign of serious circulatory blockage or other forms of heart disease. The Egyptians have used khella for heart health since the reign of the pharaohs. Khella is a natural calcium channel blocker. It prevents entry of excess calcium into the arteries, which causes constriction. Khellins affect the smooth muscle cells, while visnadins, other active agents found in the plant, favorably influence energy metabolism of the heart, increasing blood circulation of the heart muscle without raising blood pressure. This is likely due to khella's mild, positive effect on smooth muscle tissues. Khellins have been shown to dilate coronary arteries. A 1951 report in *The New England Journal of Medicine*, notes: "The high proportion of favorable results, together with the striking degree of improvement frequently observed, has led us to the conclusion that khellin, properly used, is a safe and effective drug for the treatment of angina pectoris."

Kidney Stones

Five to ten percent of women and men respectively experience at least one kidney stone episode in their lives. In fact, one of one-thousand hospital admissions in the United States are for kidney stones. Khella is an integral part of any kidney stone formula. Studies as early as the 1930s document that the tissues of the urethra are extremely sensitive to khella, which causes them to relax. This enables the urethra to open and stone to pass.

The preferred portion of this plant that should be used are the seeds of the fruit, shown on labels as *Ammi visnaga* fruit or *Fructus Ammi visnagae*.

**WHAT TO
LOOK FOR**

The most powerful and reliable Khella products are standardized according to their khellin and/or pyranocumarine (vosmadom) contents. Typically, Khella extracts are standardized for their khellin content at about 10 percent.

RECOMMENDED DAILY DOSAGE Take one standardized 100 mg tablet three times a day or the equivalent thereof if part of an overall heart health nutritional formula.

TOXICITY Higher dosages may cause queasiness, dizziness, loss of appetite, headaches, or sleep disorders in a small number of persons. Lower recommended dosages of 100 to 200 mg tend to eliminate these problems.

TWELVE /
Licorice

COMMON NAME: Licorice

BOTANICAL NAME: *Glycyrrhza glabra*

MAJOR USES
- Heartburn
- Ulcers
- Arthritis
- Asthma

BACKGROUND

Ah, licorice. Just the word brings you back to days of braided rope candy bought at the local five and dime. It doesn't take much to remember this treat's sinfully sweet taste, but did you know that licorice is actually a powerful healing herb? Licorice, although not the modern day kind found in the candy store, is one of the most widely used plants by herbalists across the globe. From civilization to civilization—Sumerians, Babylonians, Hindus, Chinese, Greeks, and Romans—right up to present day, licorice has played an integral role in medicine. Dozens of modern experimental and clinical studies have substantiated the many traditional uses of this herb, particularly for ulcers, arthritis, and abdominal pain.

Licorice is characterized by a blue-violet flower and smooth reddish-brown fruit. It thrives in river valleys with deep, fertile soil. Due to its deep penetrating root system, which sometimes stretches six feet long, licorice is difficult to harvest. Nonetheless, farmers continue to grow the hardy plant in Southern Europe, Western and Central Asia and in parts of North and South America.

The major constituent of licorice, glycyrrhizin is a sweet tasting glycoside, fifty times sweeter than sucrose.

Heartburn

Heartburn continues to increase as the American diet deteriorates. In fact, approximately sixty-million Americans suffer from incidents of heartburn at least once a month and one-quarter of persons experience heartburn daily. In response, drug store shelves are lined with antacids that promise relief, and pharmaceutical companies are enjoying hefty profits as prescription remedies increasingly account for a large portion of the pharmacy business. Though these treatments may be effective, they are often expensive and can disrupt normal digestive processes.

Licorice works so effectively because it actually stimulates the body to protect itself. Rather than inhibiting the release of stomach acids, licorice stimulates mucus-secreting cells, which in turn protect the stomach lining from irritation and infection, as well as reduce inflammation.

Ulcers

One night, while on vacation in The Netherlands, Mark Harris (not his real name) went to the bathroom, and blood literally poured out his rectum. Harris lost so much blood, in fact, that he fainted; if Harris's friend had not promptly called an ambulance and gotten him to a hospital, he probably would have died, hospital physicians later said. Harris remained in the hospital for 10 days as doctors tried to control his bleeding ulcer.

Once having returned home to Seattle, Harris's doctor gave him a prescription for a drug called Tagamet. For a while, Harris tried the more traveled mainstream road. But he quickly felt the disquieting short-term side effects associated with Tagamet. Since for so long medical science has believed excess stomach acid to be the cause of—or worsen—ulcers, drugs like Tagamet, which inhibit stomach acid secretion, are often prescribed. However, without sufficient stomach acidity, Harris could not digest his food. He suffered uncomfortable bloating and gas.

Having reached the point where the cure was as unsettling as the illness, Harris went to a naturopathic physician at Bastyr University in Seattle, one of the country's leading naturopathic centers. The doctor prescribed a chewable pill containing licorice. For a while, Harris continued taking Tagamet together with the licorice. But within six weeks, he stopped using Tagamet, while continuing on with the licorice. Harris's digestion markedly improved; his ulcer disappeared; and, he hasn't had a recurrence since being hospitalized.

Harris was fortunate to have an institution like Bastyr University in his community where he could go for help. Many other ulcer sufferers

are less fortunate and all they know is what their physician tells them. They may well end up using medical drugs like Tagamet or Flagyl off and on for years, spending thousands of dollars, while unaware of the tremendous healing powers available to them from nature's pharmacopoeia. This is not meant to denigrate mainstream physicians because they have a great deal to contribute to people's health. Furthermore, the treatment of any medical condition can be complicated and demand the attention of a qualified medical professional. But it is also important that medical consumers know there are effective alternatives available to them.

Ulcer, or peptic ulcer, is a term that refers to a number of disturbances of the upper gastrointestinal tract. The most common are duodenal and gastric ulcers. The symptoms of an ulcer include pain in the upper abdominal region, often forty-five to sixty minutes after eating, or stool in the blood. Some four million Americans presently suffer from ulcers.

Until recently, conventional medical treatment of ulcers focused on reducing gastric acidity with either antacids or drugs that block stomach acid secretion. The most commonly prescribed drugs include Zantac, manufactured by Glaxo Holdings and Tagamet, manufactured by Smith-Kline Beecham PLC. Together, the manufacturers of these drugs have enjoyed recent worldwide sales of some $4.5 billion.

Known as H-2 blockers, both Zantac and Tagamet inhibit acid production. However, if patients stop using them, they have a fifty to eighty percent chance that the ulcer will recur. Thus, the use of either drug can continue for years. Studies show that patients who use these drugs for fifteen years will spend as much as $11,500 for medication (and another $18,000 for surgery if the ulcer repeatedly bleeds).

But conventional medicine's treatment of ulcers changed radically in February 1994 when a panel of 15 medical experts, convened by the National Institutes of Health, issued a consensus statement that most peptic ulcers are caused by a bacterium called *Helicobacter pylori*, discovered by an Australian researcher only in the last decade. The panel recommended antibiotic therapy to eliminate the bacterium with the use of Zantac and Tagamet to relieve symptoms. The discovery of *Helicobacter pylori* revolutionized the medical treatment of ulcers. Fortunately, however, natural healing pathways have long recognized that the terrain is all important and the key to minimizing vulnerability to this bacterial pathogen.

This radical shift in direction did not necessarily mean medical science had discovered the true cause of ulcers; indeed, many naturopaths and physicians believe that the bacterium is simply symptomatic of a more fundamental health problem associated with the lining of the gastrointestinal tract. Furthermore, the addition of more drugs has also added additional risks to mainstream medicine's treatment of ulcers.

One antibiotic the panel recommended is metronidazole, sold by G.D. Searle, under the brand name Flagyl. Metronidazole has been known since at least the 1970s to induce cancer, including breast cancer, in rodents. Its use has been strongly criticized by Sydney Wolfe, M.D., of the Health Research Group, who in 1974 petitioned the Food and Drug Administration to severely curtail its prescribed uses. Yet even today, metronidazole continues to be widely employed by doctors even though small, statistically nonsignificant increases in cancer were reported among users of this drug in 1979 and 1982 in *The New England Journal of Medicine* and *Journal of the American Medical Association*, respectively.

Then there is Tagamet, also known as cimetidine, which has been known to cause enlarged breasts and sexual dysfunction in some men, reported researchers in 1989 in *The New England Journal of Medicine*. The ability of Tagamet to adversely affect estrogen metabolism brings up the distinct possibility that it is a risk factor for breast cancer.

That alternative practitioners do not necessarily use antibiotics or focus solely on limiting stomach acid secretion is not because they have their heads in the sand and are not dealing with the latest discoveries concerning *H. Pylori* and its association with ulcers.

The issues are simply more fundamental than excess acid secretion or the presence of *H. Pylori*, says naturopath Michael T. Murray, author of *Natural Alternatives to Over-the-Counter and Prescription Drugs* (William Morrow and Company 1994). Murray likes to speak of the "terrain" that enabled the ulcer to occur in the first place. He points out that a lot more people harbor *H. Pylori* than actually have ulcers. Thus, the gastric environment of the person who develops an ulcer must be a key factor, requiring direct healing, not symptom masking by eliminating the bacterium or inhibiting stomach acid.

In response to the fact that some persons are sensitive to glycyrrhizin and may suffer edema, hypertension, and low potassium levels, scientists have developed a procedure to remove glycyrrhizin from licorice to form

deglycyrrhizinated licorice (DGL). The result is a very successful anti-ulcer agent, rich in stomach-healing flavonoids, without known side effects.

Virtually ever medical doctor and naturopath I know agrees that the number one natural remedy for ulcers is DGL. The DGL used, however, should be supplied in chewable tablets, as the active constituents in DGL must mix with saliva in order to be most effective. This promotes the release of salivary compounds like urogastrone or epithelial cell growth factors which stimulate the growth and regeneration of stomach and intestinal cells.

The use of DGL promotes true healing by stimulating the gastrointestinal tract's normal defense mechanisms, which prevent ulcer formation. Specifically, DGL improves both the quality and quantity of the protective substances that line the intestinal tract, increases the life span of the intestinal cells, and improves blood supply to the intestinal lining.

The major issue, though, for the medical consumer is what works better: mainstream medicine with its Flagyl and Tagamet or alternative medicine with its licorice? Several studies, in fact, have looked at DGL compared with Zantac or Tagamet and have shown that alternative methods work as well or better than these mainstream drugs. For example, researchers reported in 1982 in *Gut* that DGL is as effective as Tagamet for curing gastric ulcer. That same year, *Lancet* reported DGL to be as effective as Zantac, and in 1972 researchers reporting in *Clinical Trials Journal* found DGL to be more effective than antacids. Additional studies have been published in *Practitioner* and the *Irish Medical Journal*. As for costs, Murray points out that a month's supply of Zantac or Tagamet typically costs up to $100. The cost for a month's supply of DGL is about one-quarter that amount.

"The use of deglycyrrhizinated licorice compared to standard drug therapy is a classic example of addressing the underlying cause of a condition rather than simply blocking an effect," says Dr. Murray. "Most people do not get ulcers because of oversecretion of acid; the cause in most cases is a breakdown in the integrity of the intestinal lining. While drugs like Zantac and Tagamet can block symptoms and promote temporary healing, they do not address the underlying cause and their effects arc short-lived. In contrast, DGL addresses the underlying factors and promotes true healing [by stimulating] the normal defense mechanisms that prevent ulcer formation. Specifically, DGL improves both the quality and quantity of the protective substances which line the intestinal tract; increases the life span of the intestinal cell; and improves blood supply to the intestinal lining."

More Help for Ulcers

Beyond DGL there are a number of other important natural remedies people should know about. Double-blind studies have confirmed that cabbage juice is another effective natural remedy for healing ulcers. Cabbage contains a substance called gefarnate (which itself is used as an antiulcer drug) that probably works by strengthening the stomach lining's resistance to acid attacks, notes Jean Carper in *Food—Your Miracle Medicine* (HarperCollins Publishers 1993). (Cabbage juice should be made from fresh, raw green cabbage; the recommended amount is a quart a day with results to be expected in about three weeks.) Red and white beans, corn, and unpolished rice are also protective against stomach acid, says Carper. Meanwhile, Dr. Murray recommends a diet high in fiber.

Regarding lifestyle, do not mask symptoms early on by taking aspirin or ibuprofen or consuming alcohol to quench pain. Both aspirin and ibuprofen and alcohol are dangerous to use when one has an ulcer. People also like to drink milk because it has such an immediate soothing effect on ulcers. But this effect is only temporary, lasting often only for about 20 minutes, with stomach acid secretions rebounding with even greater force. Indeed, a 1976 study from the University of California at Los Angeles demonstrated that milk drinkers often had more stomach acid than normal, and a 1986 study in the *British Medical Journal* found that milk actually delayed the healing of ulcers. Other substances that can aggravate ulcers include beer, coffee, soft drinks, and wine, note researchers at the University of California at San Diego. Emotional distress can also be a factor in the onset of ulcers, noted researchers in 1980 in the journal *Gastroenterology*.

Arthritis

Numerous studies have confirmed the anti-inflammatory effects of licorice. In one study, licorice was shown to have potent anti-inflammatory activity, similar to that of hydrocortisone. Licorice has been shown to affect the way certain steroid hormones are metabolized. Glycyrrhizin has an ability to increase the half-life of cortisol, resulting in increased anti-inflammatory action.

Asthma

The scare of blocked air passages is all too real for children and adult asthmatics. But fortunately, nature can help control this condition. Licorice has been

shown to reduce inflammation to such a degree that it can clear breathing pathways. Specifically, licorice does this by promoting the persistence of cortisol in the body, a hormone that acts as an anti-inflammatory agent.

Depending on your condition, be sure to purchase either whole-herb licorice or DGL as indicated earlier. Select only a whole herb product that is standardized to contain five percent glycyrrhetinic acid. See Resources for my recommended DGL formula. **WHAT TO LOOK FOR**

Whole-herb licorice: Take one 400 mg capsule three times daily. **RECOMMENDED DAILY DOSAGE**

DGL: Chew two 380 mg tablets, three times daily, twenty minutes before each meal.

Whole-herb licorice may cause elevation in blood pressure in some individuals. In addition, an overdose can result in hypertension, sodium retention, and edema. Withdrawal of licorice reverses these symptoms. This form of licorice in high regular dosages is contraindicated for patients with hypertension. DGL, on the other hand, poses no toxicity problems. **TOXICITY**

THIRTEEN /
Milk Thistle

COMMON NAME: Milk Thistle, St. Mary's Thistle

BOTANICAL NAME: *Silybum marianum*

MAJOR USES

- Liver disease including Hepatitis and Cirrhosis
- Adjuvant Cancer Therapy
- Skin Disorders

BACKGROUND Everyday we are exposed to a myriad of environmental pollutants. The food we eat, water we drink and air we breath are contaminated with toxins. Unfortunately, this barrage of pollutants is devastating to our health—particularly the liver.

The liver is an amazing organ, responsible for greater than five-hundred functions which directly maintain the body's various systems. In diseases of the liver, however, the body's ability to eliminate harmful wastes and assimilate important nutrients is compromised. Over time with excessive exposure to biological or chemical toxins, liver tissue becomes scarred, causing cirrhosis. Recognizing the importance of healthy liver function, ancient Greeks relied on liver tonics made from the thistle's milky fluid to enhance the function of this vital organ.

A relative of the sunflower, milk thistle is a species of prickly, but edible thistles originating from a small region in the Mediterranean. It was cultivated in Europe, and all parts were used throughout history for food, medicine, and ornament. It is a tall plant with deep, green, glossy leaves that may be eaten when young, before the spiked tips form. The flower heads can be eaten in the manner of artichokes, and the roots can be boiled and eaten. This commonly found weed was brought to North

America by early settlers, likely as a food crop, and it can now be found naturalized in areas of the western and eastern United States.

Milk thistle, also known as blessed thistle or St. Mary's thistle, gets its namesake from the milky white veins in the foliage of the plant which were said to have originated from the milk of the Virgin, hence its Latin name *Marianum*. This herb's active components have highly proven clinical applications. Its effectiveness and safety contribute to its wide acclaim as a medicinal herb.

The medicinal properties of milk thistle are found in its shiny, black seed, which appear amidst the herb's feathery down. The seeds of milk thistle have been used in the treatment of liver disease since the time of the ancient Greeks. As early as 1929, scientists were investigating the beneficial effects of the thistle plant. The liver protecting qualities of milk thistle were later isolated in what, at that time, was thought to be a single compound named silymarin. Later scientific research discovered that silymarin is composed of a complex mix of flavonoligans such as silybin, silydianin, and silychristin.

Silybin is the most highly active compound in milk thistle and one of the most potent liver-protecting substances known. It has the capacity to alter the cell structure in the outer liver membrane so that certain toxins cannot enter the cell. Extracts of silybin are even used in the treatment of inorganic and organic poisoning.

Liver Disease Including Hepatitis and Cirrhosis

MAJOR USES DEFINED

Numerous clinical trials have been conducted in Germany on the therapeutic use of silymarin in the treatment of metabolic liver damage, chronic hepatitis, bile duct inflammation and chronic liver disease. The trials show silymarin's ability to accelerate normalization of impaired liver function. In particular, silybin—an antioxidant component of silymarin that is ten times more potent than vitamin E—stimulates new liver cells to replace damaged cells. In a double blind study of its therapeutic effect in liver disorders, 129 patients with toxic liver damage, liver degeneration, and chronic hepatitis were compared with a control group of 56 patients. In 35 days of treatment, impressive results were found. The German Commission E has noted milk thistle has both preventive and curative uses in the treatment of chronic inflammatory liver disorders.

Adjuvant Cancer Therapy

Research on milk thistle's effectiveness as an adjunct therapy to traditional cancer treatments reveals another application for this herb. Milk thistle used prior to chemotherapy was found to reduce kidney toxicity without inhibiting the anti-tumor activity of the drug. Researchers concluded that the use of milk thistle's active constituents in chemotherapy patient's regimens may be useful in reducing treatment side effects.

Skin Disorders

Non-melanoma skin cancer is the most frequently diagnosed cancer in Caucasians with almost one million new cases reported each year in the United States. Fortunately, milk thistle is an antioxidant with fantastic anti-cancer properties, especially for the skin. The protective effect of silymarin, found in the seeds of milk thistle, was shown in three experimental studies of skin cancer at three different stages of the disease. Results showed topical application reduces tumor incidence significantly. The conclusion of this research project found silymarin to provide substantial protection against the different stages of sun-related skin cancer, likely due to its strong antioxidant properties. *The Journal of The National Cancer Institute* recommends further clinical study.

WHAT TO LOOK FOR

To obtain the greatest benefit from this herb, make sure you purchase an extract that is standardized to contain 80 percent silymarin calculated as silybin. In addition, look for a product that is phytosome-bound, which has been shown to increase absorption, biological activity, and delivery of the herb's active ingredients. Phytosome-bound milk thistle greatly enhances its healing benefits.

In a 1992 report in the *Japanese Journal of Pharmacology*, this new compound was compared to ordinary silybin in an animal experiment and was found to be far more effective in preventing liver damage. In fact, it showed a "significant . . . protective activity" against a wide range of assaults on the liver.

Other studies also confirm superior benefits from milk thistle phytosome. A 1991 report in *Planta Medica* notes the active ingredient in phytosome-bound milk thistle, silybin, has a bioavailability that "is several-fold greater" than its unbound counterpart.

An experimental study, reported on in 1992 in the *European Journal of Drug Metabolism and Pharmacokinetics*, indicates a "superior bioavailability." Clearly, the evidence supports phytosome-bound milk thistle extract as the best form now available.

Take one to two standardized phytosome-bound capsules daily (see Resources for information on how to obtain phytosome-bound milk thistle). **RECOMMENDED DAILY DOSAGE**

There is no known toxicity in the use of silymarin. **TOXICITY**

FOURTEEN /
Muira Puama

COMMON NAME: Muira Puama

BOTANICAL NAME: *Ptychopetaum olacoides*

MAJOR USES
- Impotence

BACKGROUND

Muira puama or marapuama is the name given to many plants from the *Olacaceas* family. However, the herbal medicine muira puama that we are talking about is a shrub that is thought to grow in only one limited region of the world, on the banks of the Rio Negro near its confluence with the Amazon River in northern Brazil. For hundreds of years the Indian tribes hid muira puama—and its remarkable medicinal properties—from their neighbors and the rest of the world.

The chemical constituents of its bark (thought to contain the highest level of its active component) include an essential oil that smells like camphor, various alkaloids, tannic acids, lupeol, beta-sitosterol, and a mixture of fatty acids. In fact, it is these fatty acids that may be the most bioactive portion of the herb with their special affinity for nerve tissue. Muira puama is most commonly used as a nerve and sex stimulant in Brazil.

There are many stories about muira puama and its discovery. One is told by reporter Alec de Montmorency who covered South America and tells us this story from the late 1880s. It was then that the healing properties of a mysterious Indian shrub which invigorated the human body in a matter of minutes were first revealed to the modern world.

Muira puama's initial claim-to-fame was its ability to help native laborers in the rubber industry centered in the Rio Negro and Amazon River region. The indigenous peoples were the laborers upon whose back this late century boom occurred. Toiling to the point of near exhaustion and highly susceptible to disease, this native population had natural prescriptions all their own. Dr. Alfredo de Matta, a physician appointed by the Brazilian government, investigated this remedy after the government cut his funding to import medicine to treat the laborers' ailments.

Further testimonies confirmed and completed de Matta's earliest descriptions. More than half a century later, Dr. Meira Penna, in his *Dicionario Brasileiro de Plantas Medicinais* (third edition, Rio De Janeiro, 1946), cited the plant's anti-rheumatic properties and reported use in dyspepsia and poor circulation.

Muira puama's fame spread to Europe in 1932 where it was used for treatment of rheumatism, menstrual cramps, impotence, partial paralysis, nervous conditions, and indigestion. In Germany alone, more than five-thousand kilos are now imported monthly, mainly for use in the treatment of impotence. The use of muira puama for sexual impotency has been the most scientifically researched, though it does have medically relevant uses for rheumatism, menstrual cramps, and nervous conditions.

Impotence

MAJOR USES DEFINED

Sexuality is a good indicator of overall health. Recent studies show that a healthy sex life is an important part of one's longevity program. Sexual relations two to three times weekly with a steady mate may actually extend life.

Impotency is fairly widespread among the United States male population due to a variety of reasons, especially vascular disease. Sometimes men need a jump start to attain and maintain an erection, a spark to ignite the flame of passion. This is why muira puama has become popular medicinal support in Germany for overcoming impotence.

"Until, Viagra, we didn't hear the mainstream medical profession speak much about aphrodisiacs," says Roger Libby, Ph.D., a nationally recognized author and clinical sex therapist. "Indeed, such a topic was taboo. Now, because the mainstream medical community has Viagra, we recognize aphrodisiacs' time has come. I prefer, however, that my own patients use nutritional supplements before resorting to a medical drug, even one

like Viagra which is now sweeping the nation. That is because herbs such as muira puama, whether used alone or in combination, create a sense of vitality and desire throughout the whole body that, for most men and women, is much more powerful and health-promoting."

Western clinical validation was lacking until 1990 when a world expert on sexual health reported his results at the First International Congress on Ethnopharmacology in Strasbourg, France. The noted French sexology consultant and member of the Gynecology-Obstetrics Department of Saint Antoine Hospital in Paris showed, under rigorous, controlled procedures, muira puama can be helpful for men suffering psychological impotence. It is particularly useful for men who are stressed out or experiencing what can only be described as a "slow loss" of their potential for desire or a loss of their ability to achieve an erection. Muira puama, however, is not a relationship cure-all or applicable to serious psychogenic disorders.

In the study, 262 patients complaining of lack of sexual desire and the inability to attain or maintain an erection were given muira puama extract. Within two weeks at a daily dose of 1 to 1.5 grams of the extract, 62 percent of the patients with loss of libido claimed that the treatment had a dynamic effect while 51 percent of patients with "erection failures" felt that muira puama was of benefit. Although the bioactivity of muira puama is unknown, it appears that it works by enhancing both psychological and physical aspects of sexual function.

WHAT TO LOOK FOR

Many experts prefer the use of muira puama over another sexual stimulant yohimbine or yohimbe bark. Where muira puama has no complications, use of yohimbe may result in anxiety, panic attacks, hallucinations, elevations in blood pressure and heart rate, dizziness, headache, and skin flushing. You can purchase muira puama as a 6:1 extract (six pounds of raw material for one pound of the extract).

RECOMMENDED DAILY DOSAGE

Take one 500 mg capsule three times daily or use the formula mentioned in the Resources section.

TOXICITY

Ingest before 4:00 p.m. to avoid difficulty in getting to sleep. Side effects are mild and have included upset stomach, headache, and mild nervousness.

FIFTEEN /
Resveratrol

COMMON NAME: Resveratrol

BOTANICAL NAME: *Vitis vinifera*

MAJOR USES
- Cancer
- Coronary Artery Disease

BACKGROUND

This fruit of the grape vine comes in many varieties, but all types are shown to have healing properties. As far back as 12,000 years ago, grapes were cultivated and used as a protective food. The juicy fruit is so widely hailed that it has been aptly coined "the fruit of life." Perhaps this is one reason so much effort is made to have grapes or their derivative available year-round. Either picked straight from the vine, dried as raisins, or pressed into wine, grapes are a real gem, and a food staple that has lasted throughout time.

The national media have done a tremendous job educating the public about the healthy effects of grapes and red wine. *Newsweek, 20/20* and the *Washington Post* have run stories supporting moderate consumption of red wine to ward off cardiovascular disease.

In recent years, interest has surfaced regarding the antioxidant effects of resveratrol, a substance extracted from grape skin. It is conceivable that resveratrol plays a role in the prevention of heart disease because it has been reported to inhibit platelet aggregation and beneficially modulate cholesterol levels.

Resveratrol can be found in a number of plants, seventy-two species to be exact. While traces are identifiable in mulberries and peanuts, the

highest quantities are found in grape skin. As for wine, higher resveratrol contents are usually present in red wines. Lower concentrations are found in young, white and rosé varieties.

MAJOR USES DEFINED

Cancer

As a leading killer of both men and women, cancer claims over one-half million lives each year. Despite medicine's best efforts, we continue to loose the battle to this deadly disease. Fortunately, scientists have turned to plant extracts in their search for cancer's cure.

In 1997, researchers at the University of Illinois at Chicago found that resveratrol helps keep cells from turning cancerous and inhibits the spread of cells that are malignant. So profound was this finding that media nationwide published the study results. Jane Brody, a veteran health writer, reported, "Grapes and red wine, already hailed for their potential to prevent heart disease, may also harbor a potent cancer inhibitor . . ."

John Pezzuto, the senior author of the study, noted, "of all the plants tested for cancer chemopreventive activity, and all the compounds we've seen, the grape has the greatest promise."

Resveratrol was chosen for the study for several reasons. First, it acts as an antioxidant and antimutagen. Second, it has strong anti-inflammatory activity. And third, resveratrol has been noted for producing enzymes that detoxify carcinogens.

Coronary Artery Disease

The integrity and strength of blood vessels is paramount to achieving maximum health. When blood vessels deteriorate, the heart must work harder and blood pressure increases.

Resveratrol is well respected in Europe for supporting vascular health. Specifically, the compound reduces edema and swelling of the veins. Such activity may be important in combating coronary artery disease. Also, resveratrol is linked to lipid metabolism, particularly production of high-density lipoproteins (HDLs, the "good" cholesterol that reduces risk of plaque formation).

Look for a product that contains 40-60 percent polyphenols, 1 to 3 percent anthocyanins and 10-30 mg trans-resveratrol.

WHAT TO LOOK FOR

Take 10-30 mg of the standardized herb daily.

RECOMMENDED DAILY DOSAGE

There is absolutely no toxicity when used as indicated.

TOXICITY

SIXTEEN /
Schisandra

COMMON NAME: Schisandra or Schizandra

BOTANICAL NAME: *Schisandra Chinensis*

MAJOR USES
- Liver Disease
- Circulation

BACKGROUND

The rocky terrain of China is home to the schisandra plant. The fruits and seeds are harvested for use in liver protection, circulatory disease, and immune support. This herb is referred to as an adaptogen. An adaptogen is defined as a safe substance that increases resistance to stress, and has a balancing effect on body functions. When ingested, schisandra increases the energy supply to cells of the brain, muscles, liver, kidneys, and nerves.

The plant's active constituent, schisandrin, has been found to act directly on the nervous system and halt convulsive activity. The majority of studies done on this healing herb originate in China where practitioners of Traditional Chinese Medicine commonly use this herb to balance bodily functions.

**MAJOR USES
DEFINED**

Liver Disease

In recent studies, schisandra, when taken regularly, has been shown to protect the liver against a number of environmental toxins such as radiation. It also helps the liver metabolize mutagens, carcinogens and other types of cell toxins.

Circulation

Schisandra has numerous positive effects on the cardiovascular system. Studies indicate it increases peripheral circulation and decreases the heart rate in non-athletic individuals. Schisandra also affects the heart's pumping mechanism. During the diastole or expansion phase of the heart's pumping action, more blood is pumped through the organ when patients receive low doses of schisandra.

Because of its calcium blocking effect, schisandra has a significant oxygen sparing action. Schisandra has been shown to be especially helpful in cases of low blood pressure.

WHAT TO LOOK FOR

Schisandra is often used in combination with other Chinese herbs such as dong quai, biota, succinum, acorus, and rehmannia. For single herb therapy, however, look for a product that contains 20 mg of schisandrins, the herb's active constituent.

RECOMMENDED DAILY DOSAGE

Take one to three 225 mg capsules of the standardized herb daily.

TOXICITY

Schisandra has very low toxicity. Those with peptic ulcers should first consult their physician before using this herb. Schisandra can increase acid levels in some individuals. In addition, persons with high blood pressure should avoid using the herb.

SEVENTEEN /
Solanum dulcamara

COMMON NAME: European Bittersweet, Woody Nightshade, Nightshade

BOTANICAL NAME: *Solanum dulcamara*

MAJOR USE
- Eczema

BACKGROUND

Of all known skin diseases, eczema is the most common. Characterized by red, itchy, inflamed scaly skin, eczema affects nearly seven percent of the world's population.

Solanum is a twining plant with purple heart-shaped leaves and bright red fruit. This sterol-rich plant grows in Britain, Europe, North Africa, and Northeastern United States. The dried stalks and unripe berries are the most useful part of the plant, containing alkaloids, saponins, and tannins. The herb is traditionally harvested in May and June.

MAJOR USES DEFINED

Eczema

Physicians often prescribe corticosteroid skin preparations. But it is important for anyone with stubborn eczema or whose doctor prescribes high-potency corticosteroids to know that there is now a safe alternative to these preparations.

Although commonly used, corticosteroid preparations sometimes cause greater complications that are more disconcerting than the condition they are being used to treat.

In some cases, persons using corticosteroids suffer from a "steroid rash" of flushed, pink flaky skin with pus-filled spots that will disappear only when treatment is stopped, reports *The American Medical Association Family Medical Guide* (Random House 1994). What's more, according to this authoritative publication, skin infections such as boils may become worse, and if you use too much of the cream, the original condition may return when treatment is stopped, probably in a more severe form. In addition, corticosteroid therapy is often symptomatic, meaning when treatment stops the skin condition reoccurs.

The skin may undergo permanent changes including thinning with blood vessels underlying the skin becoming conspicuous and stretch-marks similar to those that occur in pregnancy. Finally, the function of your adrenal glands may be diminished by too much corticosteroid med-ication, which can be life-threatening. If you do use such preparations, it is critical to use *exactly* as directed.

Also, consider my herbal alternative. Deep in forests throughout the world grows a healing herb that offers potentially tremendous relief. *Solanum dulcamara*, or European bittersweet, has a proven effect for both acute and chronic relapsing skin diseases, including eczema.

As physicians and consumers recognize the limits of modern medi-cine, plant dermatological treatments are gaining attention. In a recent study conducted in Germany, *Solanum dulcamara* ointment was given to 45 patients with chronic eczema. Following a three-week therapy, there was a clinically evident and statistically significant decrease in pru-ritus, swelling, reddening, and scab formation that was both clinically and statistically significant.

According to the researchers, "Dulcamara ointment is a reasonable and economical alternative with very good tolerance for treating mild to moderate eczema."

In another study, 536 patients were treated for pruritic dermatoses, a symptom of eczema. Within a period of one to five weeks all patients showed complete or significant reduction in symptoms.

The efficacy of this medicinal plant, both topically and orally, has been confirmed by the German Commission E. Fortunately, it is finally gaining popularity in the United States.

WHAT TO LOOK FOR

The herb may be used internally or topically. When choosing tablets, look for a 5:1 extract made from *Dulcamarae stipites* (see Resources for information on how to obtain a quality bittersweet extract formula).

RECOMMENDED DAILY DOSAGE

Adults, take one 200 mg tablet one to three times daily. Children, take one tablet daily.

TOXICITY

When used according to the recommended dosage, this formula is extremely tolerable. However, it is important to choose a standardized product and adhere to recommended dosages. Keep out of reach of children, as extremely large overdoses may be acutely toxic.

Final Thoughts on Healing

When we are young, we take our health for granted. But as we reach our thirties and forties, good health is not something any of us can expect. It is something we must work diligently at maintaining every day. By reading this book you have taken the first step toward insuring good health in the years to come.

The herbs and herbal formulas you have read about in *Nature's Guide to Healing* aren't new or simply passing fads; they are time tested and medically validated.

Whether you use them independently or as an adjunct to your conventional medical treatment, I guarantee you will see a marked improvement in your overall health.

In taking a role in your own health care there are four things you should remember:

1. KEEP A RECORD OF YOUR HEALTH HISTORY

Keeping a health diary can be an invaluable tool as you work with both your conventional and alternative physicians. Together you can make plans to avoid costly, invasive procedures, enhance prevention and live longer without complications of prescription and over the counter drugs.

2. COMMUNICATE OPENLY WITH YOUR PHYSICIAN

As you begin your journey into using alternative and complementary therapies, it is extremely important that you share your plans with your physician. In some cases it may not be wise to blend modalities. In others, the two forms of medicine may strongly support one another. The best rule of thumb is to communicate. On this same note, please do not discontinue use of a conventional medical treatment or prescription drug and substitute it with an alternative treatment or herbal formula without consulting your doctor. A qualified health professional can help you to can chart a safe course to combine both modalities.

3. BUY FOR QUALITY, NOT COST

It may be enticing to purchase the cheapest product on the store shelf, but the results can be quite disappointing. I encourage you to buy standardized herbal preparations that guarantee potency. I am encouraged by the increasing number of herbal manufacturers who are taking steps to provide uniform, high quality herbs. Look for these products first when making a purchase (see Resources for my professional recommendations).

4. MAKE KNOWLEDGE YOUR PRIORITY

The herbal industry is exploding with new products and credible scientific studies. As you journey into the world of natural medicine it is wise to keep up with all of the latest findings. After all, you may learn something that further supports your quest for good health, or that could benefit a loved one. Subscribing to a quality consumer publication such as *The Doctors' Prescription for Healthy Living* is an excellent strategy for doing so (see Resources).

Finally, enjoy the benefits of herbs the earth has to offer. Find your healing pathway to better health and you will experience deeper appreciation for natural wonders of the world and the human body.

Healing Remedies Herb Chart

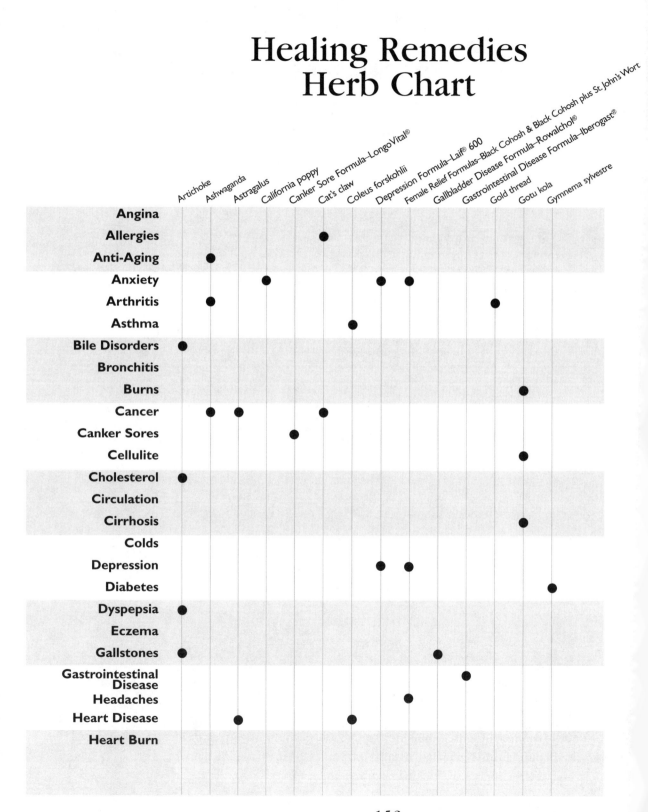

Condition	Artichoke	Ashwaganda	Astragalus	California poppy	Canker Sore Formula–LongoVital®	Cat's claw	Coleus forskohlii	Depression Formula–Laif® 600	Female Relief Formulas–Black Cohosh & Black Cohosh plus St John's Wort	Gallbladder Disease Formula–Rowalchol®	Gastrointestinal Disease Formula–Iberogast®	Gold thread	Gotu kola	Gymnema sylvestre
Angina														
Allergies						●								
Anti-Aging		●												
Anxiety				●			●	●						
Arthritis		●										●		
Asthma							●							
Bile Disorders	●													
Bronchitis														
Burns													●	
Cancer		●	●			●								
Canker Sores					●									
Cellulite													●	
Cholesterol	●													
Circulation														
Cirrhosis													●	
Colds														
Depression							●	●						
Diabetes														●
Dyspepsia	●													
Eczema														
Gallstones	●									●				
Gastrointestinal Disease											●			
Headaches								●						
Heart Disease			●				●							
Heart Burn														

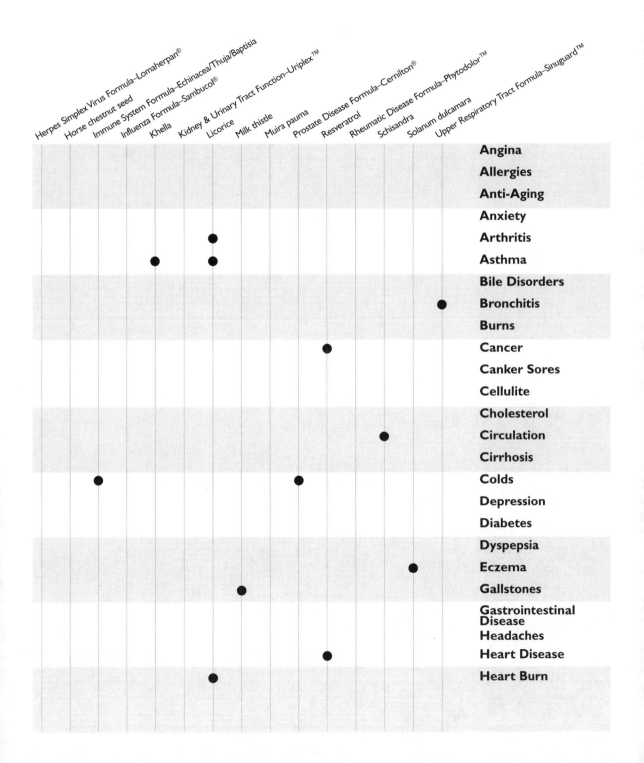

	Herpes Simplex Virus Formula–Lomaherpan®	Horse chestnut seed	Immune System Formula–Echinacea/Thuja/Baptisia	Influenza Formula–Sambucol®	Khella	Kidney & Urinary Tract Function–Uriplex™	Licorice	Milk thistle	Muira pauma	Prostate Disease Formula–Cernilton®	Resveratrol	Rheumatic Disease Formula–Phytodolor™	Schisandra	Solanum dulcamara	Upper Respiratory Tract Formula–Sinuguard™
Angina															
Allergies															
Anti-Aging															
Anxiety															
Arthritis							•								
Asthma					•		•								
Bile Disorders															
Bronchitis															•
Burns															
Cancer											•				
Canker Sores															
Cellulite															
Cholesterol															
Circulation													•		
Cirrhosis															
Colds			•							•					
Depression															
Diabetes															
Dyspepsia															
Eczema														•	
Gallstones								•							
Gastrointestinal Disease															
Headaches															
Heart Disease											•				
Heart Burn							•								

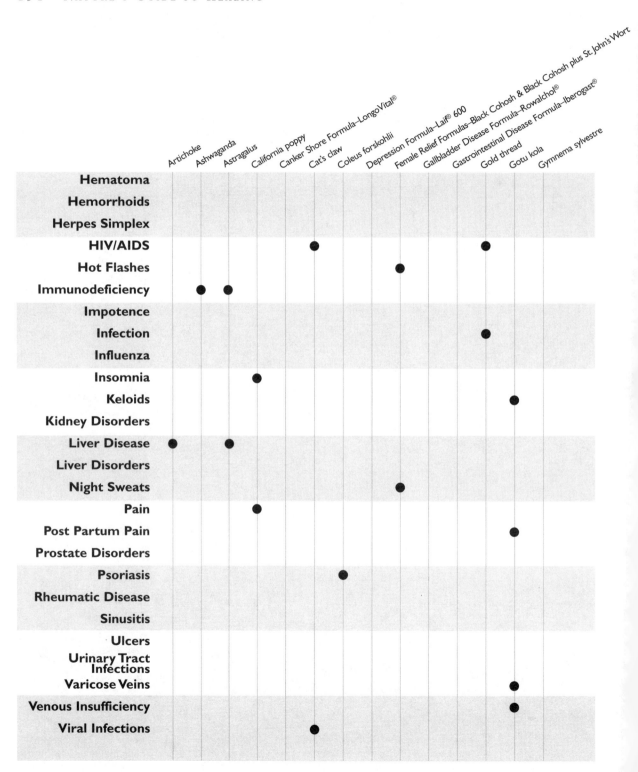

	Artichoke	Ashwaganda	Astragalus	California poppy	Canker Shore Formula–LongoVital®	Cat's claw	Coleus forskohlii	Depression Formula–Laif® 600	Female Relief Formulas–Black Cohosh & Black Cohosh plus St. John's Wort	Gallbladder Disease Formula–Rowalchol®	Gastrointestinal Disease Formula–Iberogast®	Gold thread	Gotu kola	Gymnema sylvestre
Hematoma														
Hemorrhoids														
Herpes Simplex														
HIV/AIDS						●						●		
Hot Flashes									●					
Immunodeficiency		●	●											
Impotence														
Infection												●		
Influenza														
Insomnia				●										
Keloids													●	
Kidney Disorders														
Liver Disease	●		●											
Liver Disorders														
Night Sweats									●					
Pain				●										
Post Partum Pain													●	
Prostate Disorders														
Psoriasis							●							
Rheumatic Disease														
Sinusitis														
Ulcers														
Urinary Tract Infections														
Varicose Veins													●	
Venous Insufficiency													●	
Viral Infections						●								

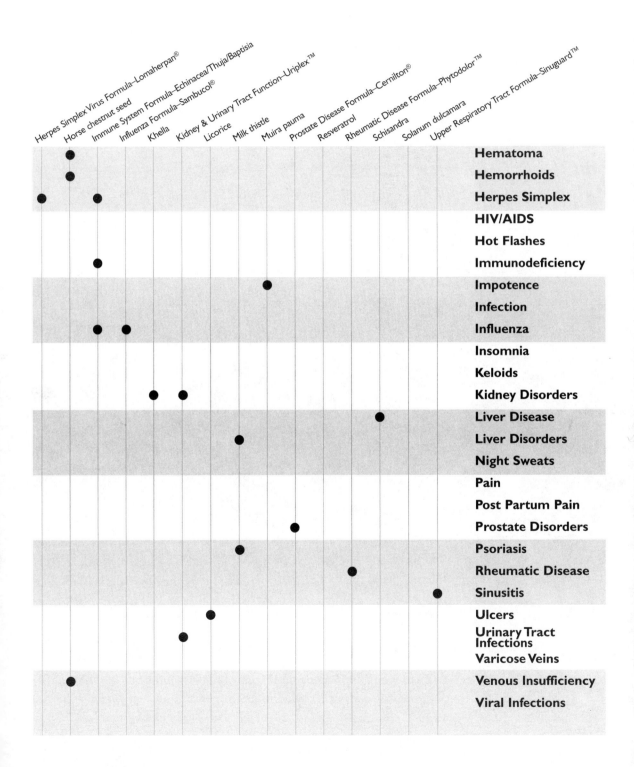

Condition	Herpes Simplex Virus Formula–Lomaherpan®	Horse chestnut seed	Immune System Formula–Echinacea/Thuja/Baptisia	Influenza Formula–Sambucol®	Khella	Kidney & Urinary Tract Function–Uriplex™	Licorice	Milk thistle	Muira pauma	Prostate Disease Formula–Cernilton®	Resveratrol	Rheumatic Disease Formula–Phytodolor™	Schisandra	Solanum dulcamara	Upper Respiratory Tract Formula–Sinuguard™
Hematoma		•													
Hemorrhoids		•													
Herpes Simplex	•		•												
HIV/AIDS															
Hot Flashes															
Immunodeficiency			•												
Impotence									•						
Infection															
Influenza			•	•											
Insomnia															
Keloids															
Kidney Disorders					•	•									
Liver Disease													•		
Liver Disorders								•							
Night Sweats															
Pain															
Post Partum Pain															
Prostate Disorders										•					
Psoriasis								•							
Rheumatic Disease												•			
Sinusitis															•
Ulcers							•								
Urinary Tract Infections						•									
Varicose Veins															
Venous Insufficiency		•													
Viral Infections															

Resources

Paramedical A/S Hoeghsmindesvej 83 DK 2820 Gentofte Denmark Tel: 45 396 565 44 Fax 45 48 18 93 83	**Canker Sore Formula– LONGOVITAL®**
Steigerwald Arzneimittelwerk Gm6M Havelstr. 5 64295 Darmstadt Germany 49-6151-3305-136 *E-mail:* info@Steigerwald.de *Website:* www.Steigerwald.de	**Depression Formula– LAIF®600**
Enzymatic Therapy 825 Challenger Drive Green Bay, WI 54311 (800) 783-2286 *Website:* www.enzy.com	**Female Relief Formulas I & II– BLACK COHOSH & BLACK COHOSH PLUS ST. JOHN'S WORT**
Rowa Pharmaceuticals Ltd. Bantry, County Cork, Ireland *E-mail:* rowa@rowa-pharma.ie 353 027 50077 *Facsimile:* 353 027 50417 *Website:* http://www.rowa.ie	**Gallbladder Disease Formula– ROWALCHOL®**

Gastrointestinal Formula– IBEROGAST™

Enzymatic Therapy
825 Challenger Drive
Green Bay, WI 54311
(800) 783-2286
Website: www.enzy.com

Herpes Simplex Virus Formula– HERPILYN®/ LOMAHERPAN®

Sold under the name Herpilyn® *in the United States*
Enzymatic Therapy
825 Challenger Drive
Green Bay, WI 54311
(800) 783-2286
Website: www.enzy.com

Immune System Formula– ECHINACEA/ THUJA/BAPTISIA

Enzymatic Therapy
825 Challenger Drive
Green Bay, WI 54311
(800) 783-2286
Website: www.enzy.com

Influenza Formula– SAMBUCOL®

Nature's Way
10 Mountain Springs Parkway
Springville, Utah 84663
(800) 962-8873
Website: www.naturesway.com

Kidney and Urinary Tract Function Formula– URIPLEX™

Enzymatic Therapy
825 Challenger Drive
Green Bay, WI 54311
(800) 783-2286
Website: www.enzy.com

Prostate Disease Formula– CERNILTON®

Cernitin of America
PO Box 544
Utica, OH 43080
(800) 831-9505
E-mail: cernitin@aUtel.net
Website: www.cernitinamerica.com

Enzymatic Therapy
825 Challenger Drive
Green Bay, WI 54311
(800) 783-2286
Website: www.enzy.com

**Arthritis Formula–
PHYTODOLOR**™

Enzymatic Therapy
825 Challenger Drive
Green Bay, WI 54311
(800) 783-2286
Website: www.enzy.com

**Upper Respiratory
Support Formula–
SINUGUARD**™

Enzymatic Therapy
825 Challenger Drive
Green Bay, WI 54311
(800) 783-2286
Website: www.enzy.com

ARTICHOKE

Himalaya USA
6950 Portwest Drive, Suite 170
Houston, TX 77024
(800) 869-4640
Website: www.himalayausa.com

ASHWAGANDA

Nature's Way
10 Mountain Springs Parkway
Springville, Utah 84663
(800) 962-8873
Website: www.naturesway.com

ASTRAGALUS

Wise Women Herbals
P.O. Box 279
Creswell, OR 97426
(541) 895-5152
Ask for their Kalmerite *formula with California poppy.*

**CALIFORNIA
POPPY**

CAT'S CLAW Enzymatic Therapy
825 Challenger Drive
Green Bay, WI 54311
(800) 783-2286
Website: www.enzy.com
Enzymatic Therapy is the exclusive North American source of the clinically validated cat's claw formula, Saventaro®.

COLEUS Enzymatic Therapy
FORSKOHLII 825 Challenger Drive
Green Bay, WI 54311
(800) 783-2286
Website: www.enzy.com

GOTU KOLA Enzymatic Therapy Nature's Way
825 Challenger Drive 10 Mountain Springs Parkway
Green Bay, WI 54311 Springville, Utah 84663
(800) 783-2286 (800) 962-8873
Website: www.enzy.com *Website:* www.naturesway.com

HORSE Enzymatic Therapy
CHESTNUT SEED 825 Challenger Drive
EXTRACT Green Bay, WI 54311
(800) 783-2286
Website: www.enzy.com
Ask about their Cellu–Var™ *formula which blends horse chestnut seed extract with butchers broom and an extremely high quality gotu kola extract.*

KHELLA Enzymatic Therapy
825 Challenger Drive
Green Bay, WI 54311
(800) 783-2286
Website: www.enzy.com
Ask for their Doctors' Choice for Heart Health *formula with khella.*

LICORICE (DGL)

Enzymatic Therapy
825 Challenger Driv
Green Bay, WI 54311
(800) 783-2286
Website: www.enzy.com
Ask about their DGL formula.

MILK THISTLE

Enzymatic Therapy
825 Challenger Drive
Green Bay, WI 54311
(800) 783-2286
Website: www.enzy.com
Ask for Super Milk Thistle™ *or* Silybin Phytosome™ *formulas.*

MUIRA PAUMA

Enzymatic Therapy
825 Challenger Drive
Green Bay, WI 54311
(800) 783-2286
Website: www.enzy.com
Ask about Masculex™ *with muira puama, their excellent men's formula.*

RESVERATROL

Natrol
21411 Prairie Street
Chatsworth, CA 91311
(818) 739-6000
Website: www.natrol.com

SCHISANDRA

Nature's Way
10 Mountain Springs Parkway
Springville, Utah 84663
(800) 962-8873
Website: www.naturesway.com

SOLANUM DULCAMARA

Enzymatic Therapy
825 Challenger Drive
Green Bay, WI 54311
(800) 783-2286
Website: www.enzy.com
Ask for their Bittersweet Extract *formula for oral use.*

GRAPE SEED
PHYTOSOME™

Enzymatic Therapy
825 Challenger Drive
Green Bay, WI 54311
(800) 783-2286
Website: www.enzy.com

To obtain the
complete German
Commission E
Monographs

The American Botanical Council
P.O. Box 144345
Austin, TX 78714-4345
(512) 926-4900
Facsimile: (512) 926-2345
Website: www.herbalgram.org

For a
brochure about
Dr. Ross' work

Please contact:
Gary S. Ross, M.D.
500 Sutter Street, Suite 300
San Francisco, CA 94102
(415) 398-0555
Facsimile: (415) 398-6228

For information
about other
available books
and books on tape
by Dr. Ross:

Ross Health
Creative Health Works
P.O. Box 2889
San Francisco, CA 94126
415-398-2855 or 800-767-7870
Facsimile: 415-642-4726
Website: www.creativehealthworks.com

The Doctors'
Prescription for
Healthy Living

The Doctors' Prescription for Healthy Living is an excellent magazine for
staying up with cutting edge information on medicine and natural health.
Subscriptions are $29.95 for 12 issues and $49.95 for 24 issues.
The Doctors' Prescription for Healthy Living
The Freedom Press, Inc.
1801 Chart Trail
Topanga, CA 90290
310-455-2995
Facsimile: 310-455-8962
E-mail: Info@freedompressonline.com
Website: www.freedompressonline.com

References

Garrison R. and Somer E. *The Nutrition Desk Reference*. New Cannan, Connecticut: KeatsPublishing, 1990.

Pederson A., "Immunomodulating effect of LongoVital® in patients with recurrent aphthous stomatitis," *Ugeskr Laeger* 153(37): 2561-4, 1991.

Pederson A., et al. "LongoVital® in the prevention of recurrent aphthous ulceration," *Journal of Oral Pathological Medicine* 19(8): 371-5, 1990.

Readers Digest Magic and Medicine of Plants. New York, NY: Readers Digest Association, 1986.

Sifton D., ed. *The PDR Family Guide to Nutrition and Health*. Montvale, NJ: Medical Economics, 576-590, 1985.

Stuart M., ed. *The Encyclopedia of Herbs and Herbalism*. New York, NY: Crescent Books, 1979.

Tierra M. *The Way of Herbs*. Santa Cruz, CA: Unity Press, 1980.

Weiner M. *Micheal Weiner's Herbal*. New York, NY: Stein and Day, 1980.

**Chapter 1
Canker Sore
Formula—
LONGOVITAL®**

Kugler J., Weidenhammer W., Schmidt A., Groll S. "Hypericum extract Steigerwald as alternative to benzodiazepine therapy," *Z Allg. Med.* 66: 21-29, 1990.

Maisenbacher J., Schmidt U., Schenk N. "Therapy of anxiety states with hypericum," *TW Neurologie Psychiatrie* 9: 65-70, 1995.

Quant J., Schmidt U., Schenk N. "Ambulatory treatment of mild and moderate depressive disorders," *Der Allgemeinartz* 15(2): 97-102, 1993.

"St. John's Wort—A plant that colors your life," Scientific Brochure, *Steigerwald Arzneimittel* GmbH, 1998.

Witte B., Harrer G., Kaplan T., Podzuweit H., Schmidt U. "Treatment of depressive disorders with a highly concentrated Hypericum preparation," *Fortscher. Med.* 113(28): 46/404-54/408, 1995.

**Chapter 2
Depression
Formula—
LAIF® 600**

Chapter 3
Female Relief
Formulas I and II—
BLACK COHOSH &
BLACK COHOSH
PLUS ST. JOHN'S
WORT

Blumenthal M. & Malone D. "Black cohosh: foreign research documents health benefits of a Native American botanical," *Whole Foods* (4): 32-34, 1998.

Daiber W. "Menopause symptoms: success without hormones," *Arzliche Praxis* 35: 1946, 1983.

Dolby V. "Natural plant estrogens are welcome by menopausal women," *Better Nutrition* 60(4): 20-25, 1998.

Lieberman S. "Evidence-based natural aedicine: a review of the effectiveness of *Cimicifuga racemosa* (black cohosh) for the symptoms of menopause," *Journal of Women's Health* 7(5): 525-529, 1998.

Liske E., Gerhard I, Wustenberg P. "Phytocombination alleviates psychovegetative disorders," *TW Gynakologic* 10: 172-175, 1997.

Perovic S., Meuller W., "Pharmacological profile of hypericum extract," *Arzheimittel Forsch/Drug Res.* 45: 1148-1149, 1995.

University of California Berkley Wellness Letter 14(12): 1-2, 1998.

Chapter 4
Gallbladder
Disease Formula—
ROWALCHOL®

Ellis W.R. & Bell G.D. "Treatment of biliary duct stones with a terpene preparation," *British Medical Journal*, 282(6264): 611, 1981.

Doran J., Keighley M.R, Bell GD. "Rowachol—a possible treatment for cholesterol gallstones," *Gut* 20(4): 312-317, 1979.

Ellis WR., et al. "Pilot study of combination treatment for gallstones with medium dose chenodeoxycholic acid and a terpene preparation," *British Medical Journal* 289(6438): 153-156, 1984.

Leiss O. & Von Bergmann K. "Effect of Rowachol on biliary lipid secretion and serum lipids in normal volunteers," *Gut* 26: 32-37, 1985.

Von Bergmann K., Beck A., Engel C., Leiss O. "Administration of a terpene mixture inhibits cholesterol nucleation in bile from patients with cholesterol gallstones," *Klinishe Wochenschrist* 65(10): 458-462, 1987.

Chapter 5
Gastrointestinal
Disease Formula—
IBEROGAST™

Fries J.F., et al. "Toward an epidemiologic of gastropathy associated with nonsteroidal anti-inflammatory drug use," *Gastroenterology* 96(2:2): 647-655, 1989.

Foster S. "Milk thistle: we need this weed!" *Better Nutrition*, October 10(59): 40-42, 1997.

Grieve M. *A Modern Herbal*. New York, NY: Dove Publications, 1971.

Mowrey D. *The Scientific Validation of Herbal Medicine*. New Canaan: Keats Publishing, 1986.

Murray M. *The Healing Power of Herbs*, Rocklin, CA: Prima Publishing, 1992.

Vogt H.J.,Tausch I., et al. "Effectiveness and tolerance of Lomaherpan® cream. Greatest effectiveness by means of an early treatment," *Der Allgemeinartz* 13: 832-841, 1991.

Wolbling R.H., Leonhardt K. "Local Therapy of Herpes Simplex with Dried Extract from Melissa Oficinalis," *Phytomedicine* 1: 25-31, 1994.

Wolbling R.H. & Milbradt R. "Clinical presentation and therapy of herpes simplex," *Therapiewoche* 34: 1193-1200, 1984.

**Chapter 6
Herpes Simplex
Virus Formula—
LOMAHERPAN®/
HERPILYN® CREAM**

Bendel, R., et al. *Onkologie*, 1989; 12(3 suppl.): 32-38.

Blunck, K.-D. *Der Kinderartz*, 1981; 14: 991-992.

Bockhorst, H., et al. *ZfA*, 1982; 58: 1795-1798.

Ernst, H.J. *Inter Praxis*, 1981; 21: 731-738.

Forth, H. & Beuscher, N. *ZfA*, 1985; 57: 2272-2275.

Frietag, U. & Stammwitz, U. *Der Kinderarzt*, 1984; 15: 1068-1071.

Pohl, P. Ther. d. Gegenw, 1970; 109: 902-906.

Qadripur, S.A. *Ther. D. Gegenw*, 1976; 115: 1072-1078.

Reitz, H.D. *Notabene Medici*, 1990; 20: issues 4-7.

Schaefer, C., et al. *Journal of Cancer research and Clinical Oncology*, 1991; 117 (supplement).

Stolze, H. & Forth, H. *Der Kassenarzt*, 1983; 23: 43-48.

Vorberg, H. Ärztl. *Praxis*, 1984; 36: 97-98.

Vorberg, H. Ärztl. *Praxis*, 1984; 36: 97-98.

**Chapter 7
Immune System
Formula—
ECHINACEA/
THUJA/BAPTISIA**

"Elderberry, an herbal remedy for the flu," *Dental Health Facts Newsletter* December 1999

"The effect of Sambucol on HIV infection *in vitro*," presented at European 7th Congress of Microbiology and Infectious Diseases, Vienna, Austria, March, 1995.

Zakay-Rones Z., Varsano N., et. al. "Inhibition of several strains of influenza virus *in vitro* and reduction of symptoms by an elderberry extract (*Sambucus nigral*) during an outbreak of influenza B Panama," *Journal of Alternative Complementary Medicine* 1(4): 361-9, 1995.

**Chapter 8
Influenza Formula—
SAMBUCOL®
LOZENGES**

Chapter 9
Kidney and
Urinary Tract
Function
FORMULA—
URIPLEX®

Bucco G.,"Nutrients detoxify and rebuild an overwhelmed immune system," *Nutrition Science News*, 1986.

MacKinnon A. & Pojar J. *Plants of the Pacific Northwest Coast*. Redmond, WA: Lone Pine Publishing, 1994.

Marti J. *The Alternative Health & Medicine Encyclopedia*, Visible Ink Press, New York, NY, 1997.

Weiss, R., *Herbal Medicine*, Gothernburg, Sweden: AB Archanum, 240-261, 1988.

Chapter 10
Prostate Disease
Formula—
CERNILTON®

Buck A.C., et al. "Treatment of outflow tract obstruction due to benign prostate hyperplasia with the pollen extract, Cernilton®," *British Journal of Urology* 66(4): 398-404, 1990.

Maekuwa M, et al., "Clinical evaluation of Cernilton® on benign prostate hypertrophy—a multiple center double-blind study with Paraprost," *Hinyokika Kiyo* 36(4): 495-516, 1990.

Malmstrom S. & Cederlof R., "Pollen as a prophylactic against the common cold," *Herba Polonica* 29(3): 229-235, 1983.

Yasumoto R., et al. "Clinical evaluation of long-term treatment using Cernitin pollen extract in patients with benign prostatic hyperplasia," *Clinical Therapeutics* 17(1): 82-87, 1995.

Chapter 11
Arthritis
Formula—
PHYTODOLOR®

Bernhardt, M., et al. "Double-blind, randomized comparative study of Phytodolor® N and placebo, and open comparison with piroxicam on patients with arthroses." *Internal Research Report*, 1991.

Ernst, E. "The efficacy of Phytodolor® for the treatment of musculoskeletal pain-a systemic review of randomized clinical trials." Department of Complementary Medicine, School of Postgraduate Medicine and Health Sciences, University of Exeter, UK.

Klose, H.H. "A phytotherapeutic for post-operative pain treatment." *Therapiewocke*, 1988; 48: 3584-3586.

Meyer, B., et al. "Antioxidative properties of alcoholic extracts from *Fraxinus excelsior, Populus tremula* and *Solidago virgaurea*." *Arzneimittelforschung*, 1995; 45(2):174-6.

Michael, J. "Treatment of rheumatic and degenerative diseases with Phytodolor N in orthopaedics," *Rheuma, Schmerz & Entzundung* 10(5): 34-38,1990.

Reiter, W., et al. "What is the effect of an antirheumatic agent with plant-based active substances in the therapy of chronic polyarthritis?" *Therapiewoche*, 1989; 39(46): 3409-3414.

Schadler W. "Phytodolor N zur behandlung aktivierter athrosen," *Rheumatism* 8(6): 280-290, 1988.

Speders S. "Phytodolor N for the treatment of degenerative vertebral column diseases," *Forum Dr. Med.*, (7:8): 29-30, 1988.

von Kruedener, S., et al. "A combination of *Populus tremula*, *Solidago virgaurea* and *Fraxinus excelsior* as an anti-inflammatory and antirheumatic drug. A short review." *Arzneimittelforschung*, 1995; 45(2): 169-71.

Weiss R. *Herbal Medicine*, Gothernburg, Sweden, AB Archanum, 257-267, 1991.

Ernst E., Siede Ch., Marz R. "Adverse drug reactions to herbal and synthetic expectorants," *The International Journal of Risk & Safety in Medicine* (7): 219-225, 1995.

Neubauer N. & Marz R.W. *Phytomedicine* (1) 177-181, 1994.

Weiss R. *Herbal Medicine*, Gothernburg, Sweden, AB Archanum, 200-209, 1988.

**Chapter 12
Upper Respiratory
Formula—
SINUGUARD™**

PART THREE

**Chapter 1
ARTICHOKE**

Adam G., Kluthe R. *Therapiewoche* (29): 5637-5640, 1997.

Cima G., et al. *Min Med.*, (50): 2288-2291, 1959.

Fintelman V. *Journal for General Medicine* (2): 3-19, 1996.

Frolich E., Zigler W. "The lipid-lowering effects of cynarin." *Subsidia Medica*, (25): 5-12, 1973.

Gebhardt R. "Artichoke extract–in-vitro proof of cholesterol biosynthesis inhibition," *Die Medizinische Welt*, 46(6): 348-350, 1995.

Gebhardt R. "Hepatoprotections through artichoke extracts," *Pharmazeutinsche Zeitung* (140): 34-37, 1995.

Hammerl H., Pichler O. *Wr. Med. Wschr*, (109): 853-855, 1959.

Held C. "Artichoke for bile duct dyskinesias. Workshop. New aspects of therapy with choleretics," *Kluvensiek* 1991.

Kirchoff R., et al. "Increase in choleresis by means of artichoke extract," *Phytomedicine* (1): 107-115, 1994.

Kirchoff R., et al. "Increase in choleresis by means of artichoke extract. Results of a randomized placebo-controlled double-blind study," *Arzliche Forshung*, (40): 1-12, 1993.

Montinie M., et al. *Arzneim-Forsch*, (25): 1311-1314, 1975.

Samochowiec L., et al. "The influence of 1,5-dicaffeolyquinic acid on serum lipids in the experimentally alcholised rat," *Pan Med* (13): 87-88, 1971.

Weiss R., *Herbal Medicine*, Gothanburg, Sweden: AB Archanum: 88-89, 1991.

Chapter 2
ASHWAGANDA

Bone K. "Withania—the Indian ginseng, an anti-aging adaptogen," *Nutrition & Healing* 5(6): 5-7, 1998.

Frawley D. Lad V. *Yoga of Herbs,* Sante Fe, NM: Lotus Press, 1986.

Kulkarni R., et. al. "Treatment of osteoarthritis with herbomineral formulation: a double-blind, placebo-controlled, cross-over study," *Journal of Ethonopharmacology* (33): 91-95, 1991.

Linder S. "Withania somnifera," *Australian Journal of Medicinal Herbalism* 8(3): 78-82, 1996.

Weiner M. & Weiner J. *Herbs that Heal*, Mill Valley, CA: Quantam Books, 71, 1994,

Ziauddin M, et al. "Studies on the immunological effects of Ashwaganda," *Journal of Ethnopharmacology* (50): 69-70, 1996.

Chapter 3
ASTRAGALUS

Bensky D. & Gamble A. *Chinese Herbal Medicine Materia Medica*, Seattle, WA: Eastland Press, 318-319, 1993.

Chang H.M., But P.P.H., eds., *Pharmacology and Applications of Chinese Materia Medica*. Singapore: World Scientific, 1041-1045, 1987.

Chu D.T., et al. "Immunotherapy with Chinese medicinal herbs," *J Clin Lab Immunol* (25): 119-129, 1988.

Zhao K.S., et al. "Enhancement of the immune response in mice by *Astragalus membranaceus*," *Immunopharmacology* (20) 225-233, 1988.

Chapter 4
CALIFORNIA POPPY

Kleber E., et al. "Modulation of key reactions of the catecholamine metabolism from extracts of *Eschscholzia californica* and *Carydalis cava*," *Arzneim-Forsch* 45(2): 127-131, 1995.

Moore M., Kamp M. *Medicinal Plants of the Pacific Northwest*, Sante Fe, CA: Red Crane Books, 1995.

Rolland A., et al. "Behavioral effects of the American traditional plant *Eschscholzia californica*: sedative and anxiolytic properties," *Planta Medica* 57(3): 202-215 1991.

Schaefer H.L., et.al. "Sedative action of extract combination of *Eschscholzia californica* and *Carydalis cava*," *Arzneim-Forsch* 45(2): 124-126, 1995.

Cerri R., et al. "New quinoic acid glucosides from *Uncaria tomentosa*," *Journal of Natural Products* 51(2): 257-261, 1988.

Davis B. "A new world class herb for A.K. practice," *Phytotherapy Research Laboratories*, Van Nuys, CA, Summer 1992.

Keplinger K, Laus G., et. al. "*Uncaria tomentosa*—ethnomedicinal use and new pharmacological toxicological and botanical results," *Journal of Ethnopharmacology* 52(4) 1998.

Keplinger K., et. al "*Uncaria tomentosa* and its active compounds," *Immodal Pharmaka*, Bundesstrasse 44, A-6111 Volders, Austria 1996.

Laus G., Brossner D., et al. "Alkaloids of Peruvian *Uncaria tomentosa*," *Phytochemistry* 45(4): 855-860, 1997.

Letters from Doctors, internal documents (1988-1997).

Mur, E., et al. "Studie zur erfassung der Sicherheit, Vertäglichkeit und wirksamkeit von KRALLENDORN®–kapseln bei patienten mit rheumatoider arthritis." Unpublished report, 1999.

Wagner H., et al. "Die alkaloid von *Uncaria tomentosa* und ihre phagozytose-steigernde wirkung," *Planta Medica* (47): 419-423, 1985.

Lichey J, et al. "Effect of forskolin on methancholine-induced bronchoconstriction in extrinsic asthmatics," *Lancet* ii: 167, 1984.

Murray M. *The Healing Power of Herbs*, Rocklin, CA: Prima Publishing, 1995

Snow J. "*Coleus forskohlii* (Lamiaceae)," *The Protocol Journal of Botanical Medicine* Autumn, 39-42, 1995.

Chapter 5
CAT'S CLAW

Chapter 6
COLEUS
FORSKOHLII

Chapter 7
GOLD THREAD

Bensky D. & Gamble A. *Chinese Herbal Medicine: Materia Medica* Seattle, WA: Eastland Press, 1986.

"Inhibitory effects of oriental herbal medicines on IL-8 induction in lipopolysaccharide-activated rat macrophages" *Planta Medica* 61(1): 26-30, 1995.

Shih-Chen L. *Chinese Medicinal Herbs*. San Francisco, CA: Georgetown Press, 125, 1980.

Chapter 8
GOTU KOLA

Boely C. "Indications of titrated extract of *Centella asiatica* in phlebology," *Gaz Med Fr.* (82): 741-744, 1975.

Boely C., Ratsimmamanga A.R. "Traitement des ulceres de jambe par l'extrait de *Centella madagascariensis*," *Presse Med* (66): 1933, 1958.

Boiteau P., Ratsimamanga A.R. "Important cicatrizants of vegetable origin and the biostimulins of Filatov," *Bull Soc Sci Bretagone* (34): 307-315, 1959.

Bonnett G.F. "Treatment of localized cellulite with asiasticoside madecassol," *Prog Med* (120): 109-110, 1974.

Borsalino G. "L'asiaticoside nella terapia di lesiono ulcerative traumatiche e varicose degli arti," *Romagna Med* (14): 335, 1962.

Bosse J.P., et al. "Clinical study of a new anti-keloid drug." *Ann Plat Sur* (3): 13-21, 1979.

Bourguignon D. "Study of the action of titrated extract of *Centella Asiatica*," *Gaz Med Fr* (82): 4579-4583, 1975.

Carro Perira I. "Treatment of cellulitis with *Centella asiatica*," *Folha Med* (79): 401-404, 1979.

Castellani L., et al. "Asiaticoside et cicatrisation del episiotomies," *Bull. Ped Soc. Gyne. Obstet. Franc.*, (18): 184, 1966.

Farris G. "L'azione terapeutica dell'asiasticoside in campo dermatologica," *Min. Med.*(51): 2244, 1960.

Gravel J.A. "Oxygen dressing and asiaticoside in the treatment of burns," *Lavel Med* (36): 413-415, 1965.

Hachen A. & Bourgain J.Y. "Etude anatomo-clinique des effects de l'extrait titre de *Centella asiatica* dans la lipodystophie localisee," *Med Prat.* (738), Supplement 7, 1979.

Keller F., Grosshans E. "Cellulite: reality or fraud?" *Med Hyg*,(41): 1513-1518, 1983.

Mazolla C. & Gini M.M. "*Centella asiatica* (TECA) in treatment of chronic venous insufficiency," *Clin Eur* (Italy) (21): 160-166, 1982.

Monograph: *Centella asiatica. Indena* S.P.A. Milan, Italy, 1987.

Murray M. *The Healing Power of Herbs*, Rocklin, CA: Prima Publishing, 173-183, 1995.

Tenailleau A. "On 80 cases of cellulitis treated with the standard extract of *Centella asiatica*," *Quest Med* (31): 919-924, 1978.

**Chapter 9
GYMNEMA
SYLVESTRE**

Baskaran K., et al. "Antidiabetic effect of a leaf extract from *Gymnema sylvestre* in non-insulin dependent diabetes mellitus patients," *J Ethnopharmacology* 30: 295-305, 1990.

Murray M. *The Healing Power of Herbs*, Rocklin, CA Prima Publishing, Inc., 227, 1992.

Shanmugasundaram ERB, et al. "Use of *Gymnema sylvestre* leaf extract in the control of blood glucose in insulin-dependent diabetes mellitus patients," *J Ethnopharmacology* 30: 281-294, 1990.

**Chapter 10
HORSE
CHESTNUT
SEED**

Calabresse C., Preston P. "Report of the results of a double-blind, randomized, single-dose trial of a topical 2% escin gel versus placebo in the acute treatment of experimentally induced hematoma in volunteers," *Planta Med.* (59): 394-397, 1993.

Diehm T., et al. "Comparison of leg compression stocking and oral horse chestnut seed extract in patients with chronic venous insufficiency," *The Lancet* 347: 292-294, 1996.

Pittler, M.H. & Ernst, E. "Horse-chestnut seed extract for chronic venous insufficiency. A criteria-based systematic review." *Arch Dermatol*, 1998; 134(11): 1356-1360.

**Chapter 11
KHELLA**

Asrep G.V., et al. "Coronary vasodilator action of khellin," *Am Heart J* (37): 531-542, 1949.

Conn J.J., et al. "Treatment of angina pectoris with khellin," *Annals of Internal Medicine* 1173-1178, 1952.

Osher H.L., et al. "Khellin in the treatment of angina pectoris," *The New England Journal of Medicine* (224): 315-321, 1951.

Samaan K. "The pharmacological basis of drug treatment of spasm of the ureter or bladder and or ureteral stone," *British Journal of Urology* (5): 213-224, 1933.

Chapter 12
LICORICE

Kassir ZA. "Endoscopic controlled trial of four drug regimes in the treatment of chronic duodenal ulceration," *Irish Medical Journal* (78): 153-156, 1985.

Murray M. *The Healing Power of Herbs*, Rocklin CA Prima Publishing, 158-166, 1992.

Steinman D. "Healing Ulcers Safely," *The Doctor's Prescrption For Healthy Living* 2:1, 1998.

Chapter 13
MILK THISTLE

Katiyar S., Korman N., Nuktar H., Agarwal R., "Protective effects of silymarin against phytocarcinogenesis in a mouse skin model," *Journal of National Cancer Institute* 89(8), 556-566, 1997.

Murray M. *The Healing Power Of Herbs*, Rocklin, CA Prima Publishing, 244, 1992.

Spaulding-Albright N. "A review of some herbal and related products commonly used in cancer patients," *Journal of the American Dietetic Association* 97(109): 208, 1997.

Chapter 14
MUIRA PUAMA

De Montmorency A. "Rare plant has therapeutic value," *Spotlight* March 5, 1984.

Waynberg J. "Aphrodisiacs: contribution to the clinical validation of the traditional use of *Ptychopetalum guyana*," Presented at the First International Congress of Ethnopharmocology, Strasbourg, France, June 5-9, 1990.

Chapter 15
RESVERATROL

Celotti E., Ferrarini R., Zironi R., Conte L. "Resveratrol content of some wines obtained from dried Valpolicella grapes," *Journal of Chromatography* (730): 47-52, 1996.

Jang M., Cai L., et. al. "Cancer chemopreventive activity of resveratrol, a natural product derived from grapes," *Science Vol* 275: 218-220, 1997.

Recer P. "Study: grapes may help curb cancer," *Austin American-Statesman* Jan. 10, A2, 1997.

Web G. *Herb Clip* 110875; The American Botanical Council, 1997.

Chen Y.Y. et al. *Scientia Sinica* (1): 98, 1976.

Chu Y., Wang M. "Aspects of schizandrin metabolism *in vitro* and *in vivo*," *European Journal of Drug Metabolism and Pharmacokinetics* 18(2): 155-160, 1993.

Jiangsu College of New Medicine. *Encyclopedia of Chinese Materia Medica*. Shanghai People's Publishing House. 386, 1997.

Tenney L., *Today's Herbal Health*, Pleasant Grove, UT: Woodland Publishing 146, 1997.

Chapter 16
SCHISANDRA

Oestrich W., Stoeter, M. "Topical eczema therapy with phytopharmaceutical," *Journal of Skin Diseases* 14, 1996.

Chapter 17
SOLANUM
DULCAMARA

About the Author

Gary S. Ross, M.D. has been in private practice with an emphasis on complementary and preventive medicine for 22 years. He is a professor of clinical medicine at Meiji College of Oriental Medicine, Berkeley, California. He lectures regularly to physicians internationally. He is on the medical scientific advisory boards of several publications and is an independent consultant within the health industry. Dr. Ross is the author of *Men's Health in Action* and other audio and video programs. He received his medical degree from George Washington University School of Medicine and did residency training in internal medicine. He is recognized for his broad understanding of the practical application of the many treatment modalities used in complementary medicine today.

GARY S. ROSS, M.D.